THE
DON DAVY
MANUAL OF DRAWING

THE
DON DAVY
MANUAL OF DRAWING

BLANDFORD PRESS
POOLE NEW YORK SYDNEY

First published in the UK 1986 by Blandford Press
Link House, West Street, Poole, Dorset BH15 1LL

Distributed in the United States by
Sterling Publishing Co. Inc,
2 Park Avenue, New York, NY 10016

Distributed in Australia by
Capricorn Link (Australia) Pty Ltd
PO Box 665, Lane Cove, NSW 2066

British Library Cataloguing in Publication Data

Davy, Don
The Don Davy drawing manual.
1. Drawing—Technique
I. Title
741.2 NC730

ISBN 0 7137 1765 3 (Hardback)
 0 7137 1766 1 (Paperback)

Typeset by Best-set Typesetter Limited

Printed in Great Britain by
R.J. Acford Ltd., Chichester, Sussex

Contents

Acknowledgements	6	Water and Reflections	56
Dedication	7	Sky and Clouds	61
Introduction	8	Boats	63
Materials and Equipment	9	Buildings	68
How to Start	12	Transport	78
Technique	13	Trees	84
Tone, Light and Shade	16	Flowers	94
Blocks and Planes	19	Still Life and Objects	104
Perspective	21	Figure Drawing	114
The Sketch Book	24	Portraiture	132
Sources	27	Constructing Pictures	139
Photographs	36	Decoration	145
Animals	38	Pen, Brush and Charcoal	150
Birds	47	Conclusion	160

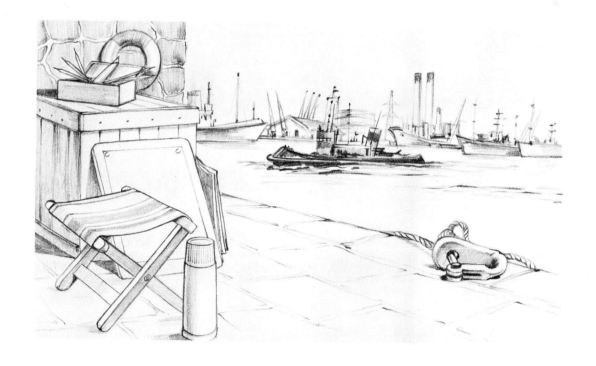

Acknowledgements

My thanks are due to the following people
and organisations for their help in my
preparation of this book: –

Sylvia Davy
Justin Davy
Sydney Foley
Brian Gallagher
Violette Shebini
Celia Featherstone
Sonia Kennerly
John Kennerly
Chessington Zoo
Natural History Museum
Leatherhead Library

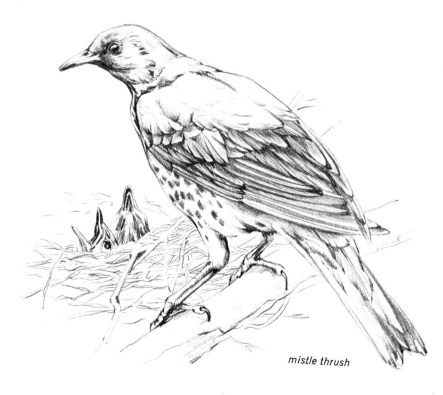

mistle thrush

Dedication
To All My Colleagues

If as draughtsman you wish to study well and profitably, accustom yourself when you are drawing to work slowly, and to determine between the various lights which possess the highest degree of brightness and in what measure, and similarly as to the shadows which are those that are darker than the rest, and in what manner they mingle together, and to compare their dimensions one with another; and so with the contours to observe which way they are tending, and as to the lines what part of each is curved in one way or another, and where they are more or less conspicuous and consequently thick or fine; and lastly to see that your shadows and lights may blend without strokes or lines in the manner of smoke. And when you shall have trained your hand and judgment with this degree of care, it will speedily come to pass that you will have no need to take thought thereto.

LEONARDO DA VINCI

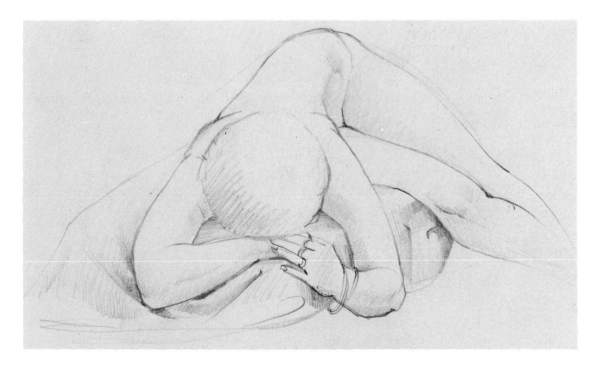

7

Introduction

What is drawing?

The simplistic answer to this question is, 'making marks on paper with a pencil to represent a view of an object' but immediately the mark is made the questions start flooding in. Is the mark in the right place? Is it too light or too dark? How is the next mark to be made so that it is in the correct relationship to the original?

The age-old response to the question 'Why not draw?' is 'I cannot even draw a straight line.' If a dead straight line needs to be drawn then there is no reason why a ruler should not be used; but how often is a dead straight line needed? In artistic terms I would hazard almost never.

There are two ingredients necessary for the student mind. One, the will and desire to learn; and two, the patient application necessary to acquire the skills by constant practice. Just as it is necessary for a musician to practise scales in order to aspire to perfection, so it is required of artists to strive always to improve their art.

Since it is possible to reproduce accurate pictures in black and white or colour by using a camera, why bother with drawing and painting? Commonly it is assumed that the purpose of drawing is to capture a subject accurately and make it appear in a three-dimensional form – so if we persist in drawing instead of using a photograph, what is it that drives us on?

Most artists who have been drawing for some time feel that the very act of putting pencil to paper is itself satisfying and every subject is a challenge. It could be said of drawing that it is an art of selection. It is not necessarily an accurate collection of facts, but more a representation of a chosen aspect of the subject.

The photograph will gather every bit of information which is encompassed within the range of the lens of the camera. The human eye and brain can also do this, but usually reject this approach. Instead there is a focal point of interest which captures the artist's eye. The focal point is usually given prominence in the making of the picture, and the surroundings are muted or altered to improve the design.

Whereas there is a certain impersonality about a photograph, a drawing encompasses the vision, spirit, skill and heart of the artist. This can be seen when a drawing is compared with a photograph, although it is very difficult to define in words.

We have always found it necessary to express ourselves in visual terms; to say what we feel about the world about us. It is a spiritual and emotional, as well as a practical, exercise which in itself helps us to grow and reach a greater awareness of our existence and place in the overall scheme of things.

So we shall always want to draw. Once embarked upon, drawing will be found to be a challenge and excitement which never diminishes. There is much joy and occasional heartache, but we cannot stop. There are no short cuts but there is a wealth of guidance, some of it to be found in this book. With a will and diligent practice, the aspiring artist will acquire a lifetime of enjoyment and a great sense of achievement.

Materials and Equipment

Although drawing generally indicates the use of a pencil, this need not always be the case. One can draw with anything; pen, brush, charcoal, conte coloured crayons, even fingers (when one becomes more proficient and desires to experiment). A collection of all these tools may be of benefit.

When selecting your tools, always try to achieve the best quality you can afford, and invest in a box to keep them all safe. The sort of container in popular use these days is the plastic tool box. Easy to carry and with many compartments, it comes in a variety of sizes.

Pencils

When buying pencils, it is well to select some reasonably soft ones, from a B through to a 3b or 4B. For later use, when wishing to indulge in colour, there are some very good coloured pencils and crayons available in easily transportable containers.

Knife

A good sharp knife is the best tool to sharpen your pencils or crayons. Pencil sharpeners are useful, but they are very limited and cannot sharpen your tool to the same extent.

Pens

Ordinary mapping pens may be used to give a varying line, depending on the pressure applied. The danger with mapping pens is the possibility of 'digging' the pen into the paper and splattering ink all over your work. Alternatively, there are some excellent but more expensive types of technical drawing pens which can be used very successfully. These usually have their own built-in reservoir of ink available in various colours.

If you wish to go to a little more trouble, it is possible to make a 'natural' pen from either a goose quill or a piece of wood.

Inks

Black waterproof ink is an obvious choice and it is extensively used. Such ink is useful to keep in your armoury, but there are many colours from which to choose. It is also possible to make your own ink, particularly when a softer effect is required. This can be achieved by mixing a solution of watercolour paint in any strength required and storing it in a screw-topped bottle ready for use.

Brushes

A brush can be used for fine lines as well as for laying broad tones. Both inks and watercolour are good media for brushes.

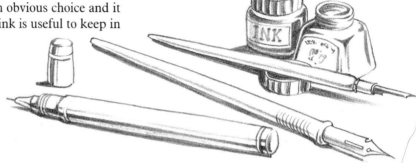

Charcoal

Good quality charcoal helps to keep your drawing broader and generally less fussy; it also helps to lay in areas of tone quickly. Furthermore, it is possible to add details by using the sharp edge of the stick. With charcoal, as well as with pencil, it is possible to draw with an eraser in order to take out tone and add lighter areas. A good quality putty rubber is ideal for this purpose. Conte and pastel crayons can be used in the same way. When using this type of medium it is advisable to apply a spray fixative from an aerosol can, otherwise the drawing may be smudged and spoiled.

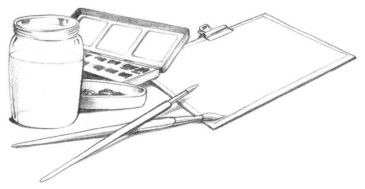

Paper

A sketch book of ordinary cartridge paper is essential and should be extensively used. It is always useful to have a small pocket size book with you at all times so that notes can be made and augmented later. When using watercolour it is as well as to use a sketch book of watercolour paper. As far as charcoal and crayons are concerned there are many types of paper available including colour, which can be very effective, these can be bought in separate sheets or in book form.

Other bits of equipment which will be found invaluable are a drawing board, pins or clips, a water jar (small jam jar with a screw top), and a collapsable stool.

When going out sketching it is not necessary to take everything along with you, so try to select your most appropriate equipment for the job in hand. A sketch book, pencils, knife, eraser and a stool: – most of this can be packed into a canvas shoulder bag. For a little extra comfort a thermos flask for a drink can be most welcome. Do not forget to select the correct clothing. If it is a bit chilly, wrap up warmly; you cannot draw if you are shivering.

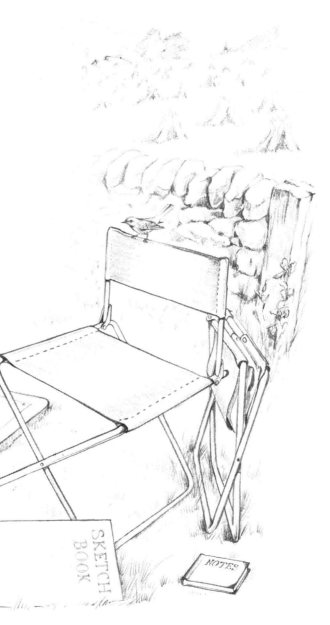

How to start

To give ourselves the best possible chance of achieving success, it is necessary to create conditions in which as little as possible stands between the image on the paper and our visual conception of the model. Let us be as uncomplicated as possible in our approach.

Primarily, we should concern ourselves with our tools and materials, and for the sake of simplicity I am not going to elaborate on the various media which may be used, but just concentrate on the pencil. Try to remember though, that whatever medium you choose to use, you should find the best that you can afford and use it directly and in an uncomplicated manner.

The pencil

To achieve a sympathetic line and to give maximum coverage where required, it is wise to select a fairly soft pencil, perhaps a B or a 2B. Use a sharp knife for sharpening and ensure that you have sufficient lead exposed to give you freedom of action. Do not forget to maintain your pencil point throughout your drawing.

How to hold the pencil

It may seem presumptuous to mention the position in which you hold your pencil, but as with all tools there is a right and a wrong way to use it. Look at the illustrations and see how the position of your board and paper determines the position in which you hold your pencil.

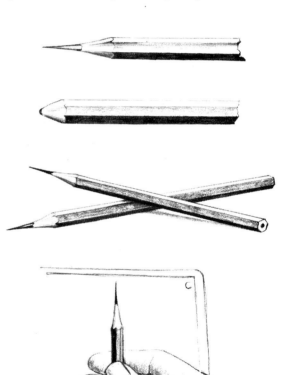

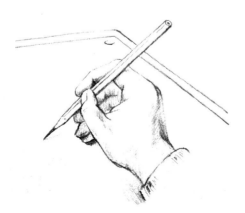

12

Technique

It may be an obvious thing to say, but by making different marks on paper it is possible to give the illusion of varying textures. Technique is as much a tool as the pencil, pen or brush, and paying attention to the way different marks can be made on paper will add to your repertoire of illusions. I like to think of it as 'Thinking with the pencil'. Making marks gives one visual and mental stimulus. Drawing cannot all be done in the mind: what comes from the tip of the pencil is the culmination of the seeing eye, the mental translation of the image and the physical co-ordination of the hand to create a visual result. The result will be the proof, or otherwise, of your deliberations.

You will notice throughout these pages that there is no mention of artistic flair or the use of the imagination (in the abstract sense). The emphasis is wholly on the nuts and bolts of straightforward observation and acquisition of technique. Once this is understood then anyone can train themselves to draw in a representational way.

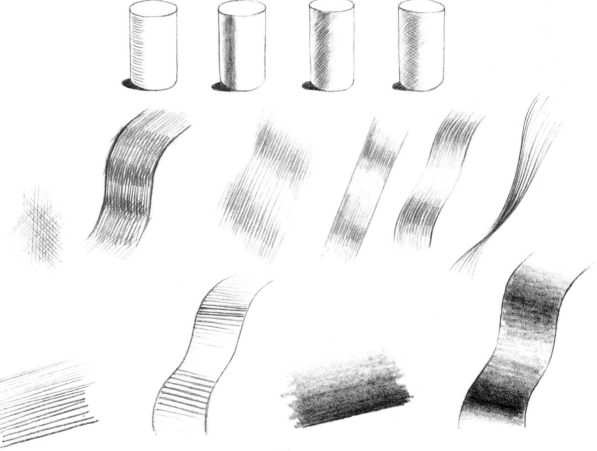

13

The illustrations of the cylinders show just four different ways of portraying the same object in three dimensions. It is good practice to play with the pencil to see what illusions can be created using different techniques.

By using the pencil in differing ways the illusion of various textures can be given. The illustration of the coat uses a combination of soft and hard techniques which indicates the thick woolly material, and lines are only used to dilineate where one area starts and another finishes. Note that the shaded areas, which denote a soft curve from one space to another have few hard lines, and the only hardness appears where there is a sharp fold causing a dense shadow.

By contrast the drawing of the bottles is almost entirely hard and the dark reflective areas are solid. Even the half tones are clearly defined with no fuzzy edges. When studying a bottle it takes only a little practice to seek and find the abstract shapes of the various dark and light areas. If one concentrates on drawing the shapes seen and leaving the shape of the bottle almost as a secondary consideration, suddenly all becomes quite clear and in no time at all a hard, brittle piece of glass appears on the page.

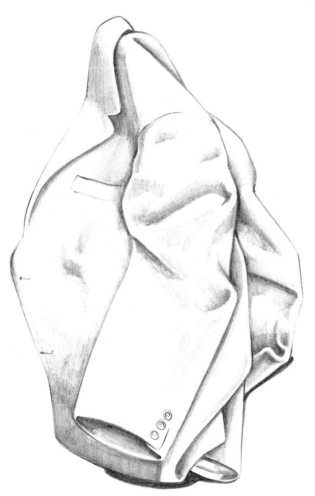

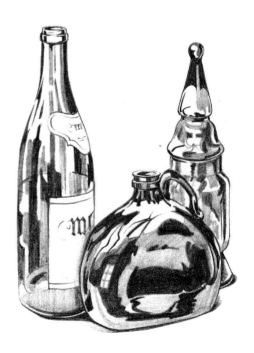

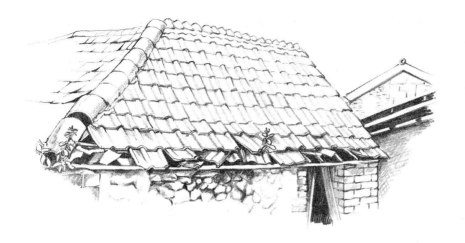

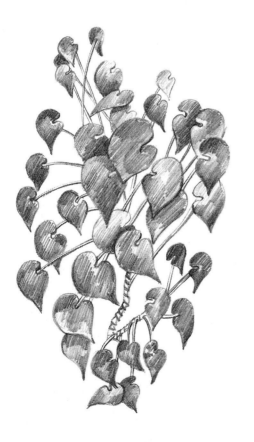

Other techniques should be practised and it is a good idea to choose subjects which inherently suggest the technique to be used. For example, the farm building roof in a hard light almost forces the artist to draw it as he (or she) sees it. The varying hard lines and soft curves of the tiles are interspersed with the very dark areas where the tiles are broken or missing. In this simple sketch there is a host of interesting details.

The Begonia leaves suggest a lovely pattern of similar shapes in a cascade of differing sizes. As the shapes are similar the technique they suggest is ordered and regular; therefore a shaded pattern of areas of line is used, with no pretence of trying to reproduce the details of the actual leaves. This sketch is another exercise in practising techniques that are suitable for the subject: a good objective for the enthusiastic student.

15

Tone, Light and Shade

Because we have two eyes, everything appears to us in solid three dimensions, but we find that light or sometimes the lack of it can play tricks on us. The three-dimensional image is therefore more obvious if the lighting is used to its best advantage.

When drawing an object and creating an image on paper it is essential to use tone, light and shade to achieve the correct illusion.

Sometimes when light is flooded all over the subject and it appears bland and possibly difficult to see, it may be useful to create our own light source to achieve a more realistic effect. It may be argued that the heavier the dark areas

the more dramatic the drawing. It is fun to experiment and find out which is the most appealing to you in relation to your subject.

An experiment you may like to try in your own home is a simple one of selecting an object and placing it against a plain white background. Take a bright lamp and hold it directly in front of the object so that it casts few shadows. Now move it from one side to another and note how the moving shadows pick out the details and make them more visible. (The illustration below showing a simple cube and ball will suggest the method to use.)

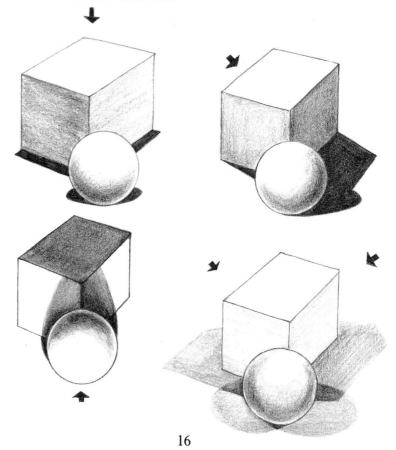

16

To make effective use of light, the source has to be determined and then adhered to. It is one of the methods used to establish the three dimensional image. The examples using simple geometric forms illustrate the broad outline of the principles involved. The arrows give the direction of light.

The elephant was drawn with the light source above and in front of the animal, and it will be noted that areas turned furthest away from the light are darker than other areas turning nearer to the light. It will also be noted that the block and plane method has been used and extended to include heavy shadows.

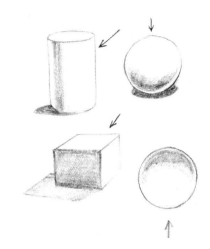

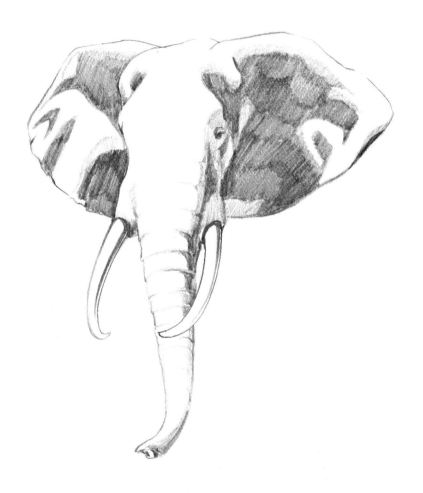

The effect of light and shade is very important to consider as it can make or break a drawing. It is one of the components in drawing to recognise, as valuable as reflections, perspective and composition in getting the best out of your pictures, as well as adding a certain drama and authenticity. The illustration on this page of the rowing boat in absolutely still water shows how a hot summer's day can be portrayed by flooding the whole picture in white light; only the slightest hint of dark areas are used.

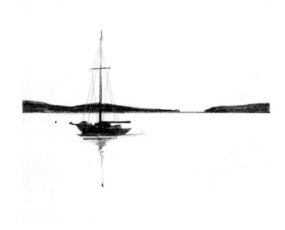

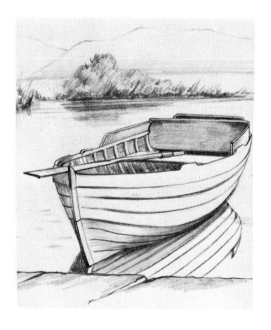

The illustration of the sailing boat denotes 'back lighting' to make effective use of silhouettes and reflections. Sky and water are wonderful mediums for achieving space in our pictures. There is an element of limitless expanse which for the most part can be attained by drawing almost nothing.

By selecting the most important components – in this case a boat, a few hills in the distance and a reflection – and drawing them in hard black shapes, a picture of space, tranquility and calm is created. Experiment with other types of scenes to try to achieve a similar atmosphere.

Blocks and planes

One of the methods of gaining the appearance of solidity is to use the 'block and plane' approach. By looking at these illustrations, it will be seen that most of your drawings may be seen as large blocks at first and then these can be broken down into smaller and smaller ones covering the whole drawing. Once these have been established, smaller planes may be added until the main basic of the drawing is complete. The stronger the light on the subject, the easier to see the planes thrown up by the shadows.

It may be simpler to investigate this method by using a good photograph and breaking it down into its' block and plane components, as seen in the illustrations. As one becomes familiar with 'seeing', it will not be so necessary to put in every little nook and cranny but merely to suggest form by judicious use of shading in the right places.

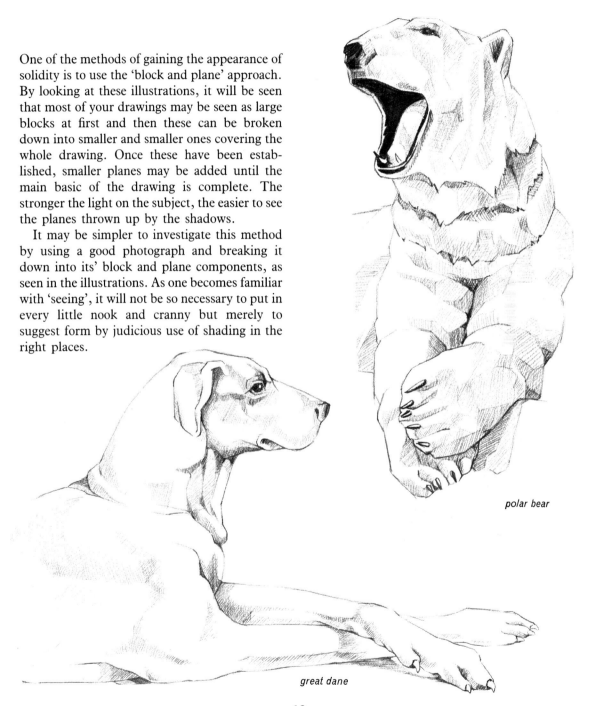

polar bear

great dane

19

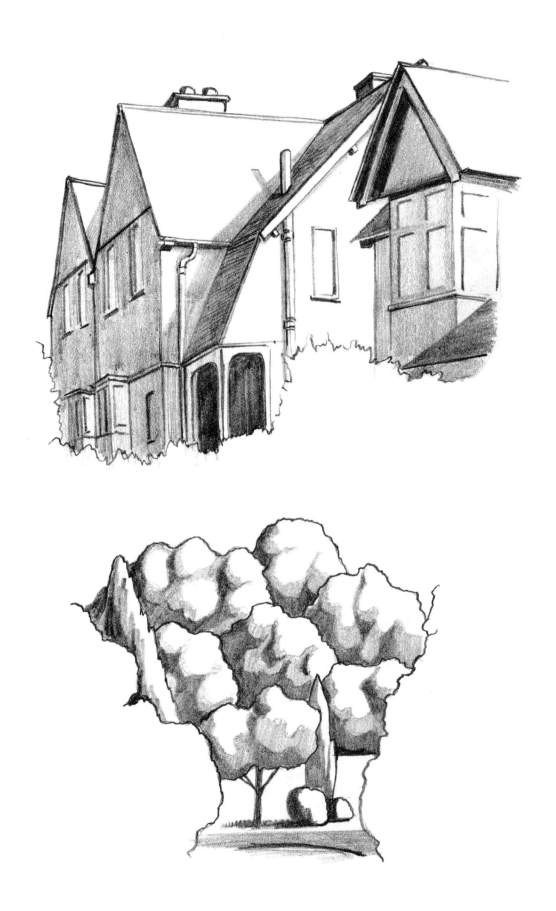

Perspective

It is necessary to have a simple working knowledge of perspective to make our drawings of buildings appear solid and convincing. If we remember that most things can be reduced to boxes this exercise should present few difficulties.

The horizon, or eye-line, is the first thing to consider. Wherever you are placed in relation to your subject is the determining factor in establishing your perspective. Let us take this one step at a time. To find the horizon line you want you must consider how you wish to portray your subject matter. Fig. 1 illustrates the normal view one has of a building, i.e. where the eye is level with the doorway, about 5' 6" from the ground.

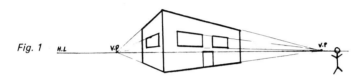

Fig. 1

Now if it is desired to make a building appear bigger and grander, it is necessary to lower one's eye-line to ground level for a worm's eye view.

In Fig. 2, the artist is lying on the ground with the building towering above.

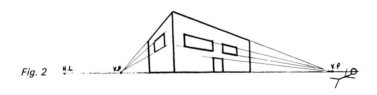

Fig. 2

The final aspect to remember is where the subject can be made to look small, similar to a doll's house, by raising the eye high in the sky above the subject. Fig. 3 illustrates how this is done.

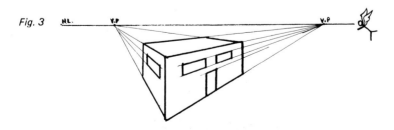

Fig. 3

Having established where we want our eye-line, it is time to find out how to put the simple rules of perspective into practice. Here we are dealing mainly with parallel perspective, which means that lines parallel to each other converge on the same vanishing point. To understand what a vanishing point is, look at Fig. 4 and imagine that you are standing on a desert with a straight road disappearing to the horizon. Although we know that the two lines of the road edges are the same width all the way along, the appearance is that they go away from us and converge at one point, vanishing on the horizon. Parallel lines always vanish to one point on the horizon.

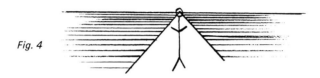

Fig. 4

Let us see what this concept looks like when it is applied to a box-like structure. Fig. 5 shows two sides of a box with the eye-line established in the middle. Each side has two parallel lines and therefore two vanishing points. The placing of the vanishing points is a matter of practice, but it should be remembered that the more one can see of the side of a building the further the vanishing point is from the leading edge, and conversely the less seen of the side of the building the nearer the vanishing point is to the leading edge.

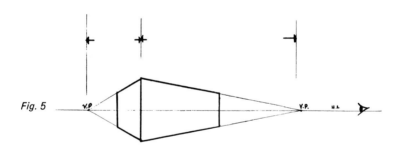

Fig. 5

For all practical purposes the vertical lines are placed where appropriate and kept absolutely vertical.

Let us work out how to put a roof on to our box-like building. To find the apex of the roof, we must first of all find the main lines of the hidden part of the building. Fig. 6 shows us how this is achieved. Fig. 5 is drawn again, then the hidden lines are drawn, following the rule that parallel lines must disappear to the same vanishing points. The appearance of our drawing is now that of a glass box.

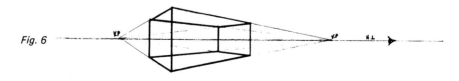

Fig. 6

We now have to find the centre of the side of the building where we wish to project the gable end. This is very simply done by drawing two diagonal lines from corner to corner, which gives us a centre point; then we can project a vertical line through this, see Fig. 7. Somewhere along this line the apex point of the roof is fixed.

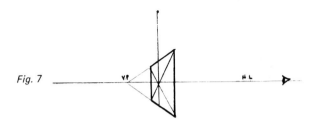

Fig. 7

A line is then drawn from the apex point to the appropriate vanishing point. See Fig. 8.

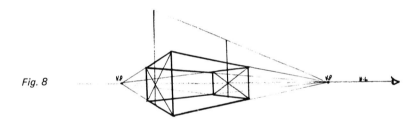

Fig. 8

Now all we have to do is to join up the points from the apex to the edges of the roof and we have a simple building cube with a roof. See Fig. 9.

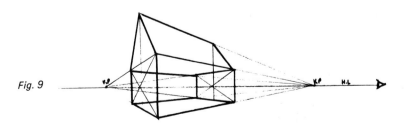

Fig. 9

23

The Sketch Book

The artist's eye and vision encompasses everything; no subject is too ordinary or mundane. To make one's pictures authentic it is necessary to pay attention to detail.

The sketch book is an essential part of the artist's equipment and should be used to jot down notes of every conceivable object. Not only is it good practice to keep the hand and eye in trim but you never know when an object will be required for inclusion in a picture.

To start with, look around your own home – not only are there animate objects, people, animals etc. but there are many inanimate objects such as furniture, parts of the building, bowls of flowers, clothing, tools, kitchen equipment and so on. Draw as many of these as possible in the comfort and security of your own home.

Later, go outside. Here the choice is limitless – things such as lamp-posts, drain covers, tombstones, buildings, buses, cars, trees, skies, water, people and so on. Wherever you look there is something of interest to be drawn and you will find that it is fun and satisfying to draw just for its own sake and the physical and mental pleasure it gives. Added to all these studies is the bonus of observing light, shade and texture, shiny and dull surfaces. There is so much to be enjoyed. The pure observation of our environment adds immeasurably to our knowledge and awareness.

All this and more is part of the artist's essential equipment and the sketch book is the memory bank. You never know when you may wish to make a withdrawal. It is interesting to note that once an object has been drawn, even without the first-hand information to refer to, the computer in your head retains much of the detail, which can then be recalled.

The best source of information is always the real live object, but sometimes it is necessary to refer to other sources, such as photographs, museums and even other artists' works.

Sources other than original sources, must be treated with extreme caution because they are limited in many ways in relation to the artist and his or her particular work. Although never be too proud to learn from others; however experienced one is, there is always something to learn from others.

Have a look at the illustrations throughout this chapter and the one following. Many varied subjects have been chosen to stimulate the ideas and it is always a good idea to practise the co-ordination of hand and eye, a little each day. It becomes automatic and almost as necessary to you as eating and breathing.

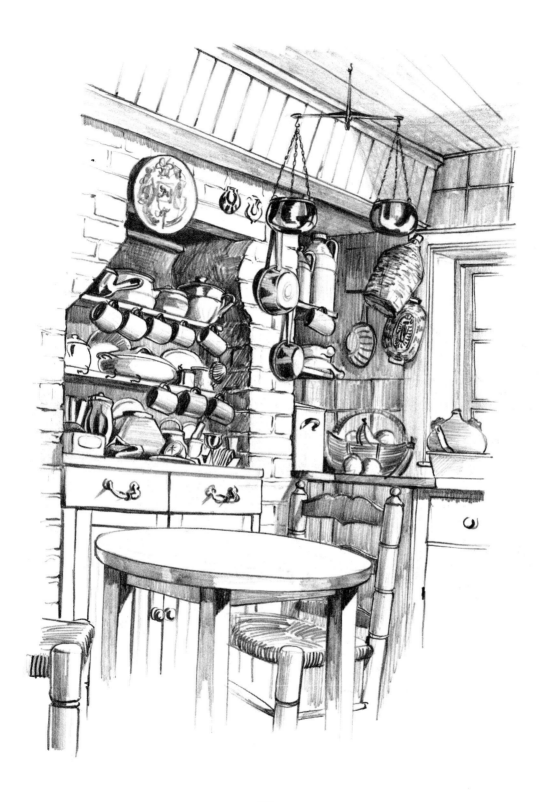

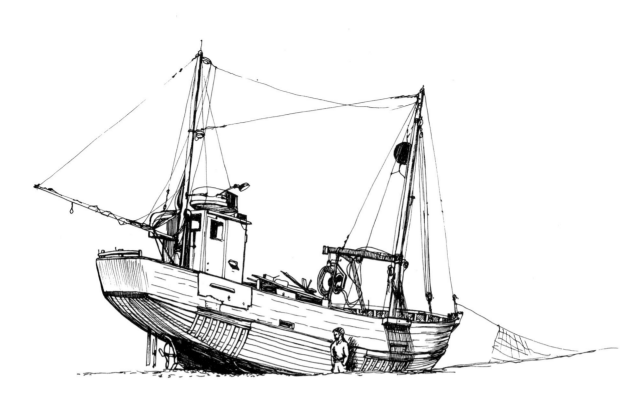

Note the variety of subjects. All these drawings are selected from my own sketch books and are chosen for their diversity, from a shiny motor cycle and collection of mechanical 'bits' to animals, people, flowers and trees.

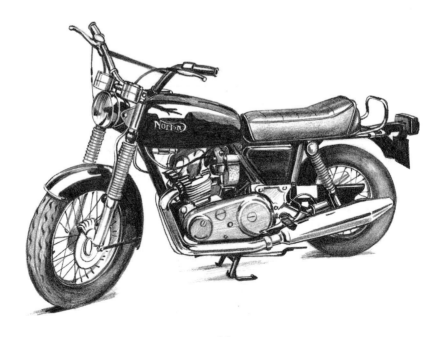

Sources

It could loosely be said that anything anywhere is a source for artistic interest and endeavour. Nothing should be overlooked. In this respect the sketch book is a convenient way to assemble all the things which may be of use at a later date, or it may come in handy simply because we like to draw things for their own sake.

Drawing objects from real life is always best but other sources such as photographs should not be ignored. Artistic thought and enterprise takes many forms and ideas may strike at any time. It is prudent always to have a sketch book and pencil handy to jot down ideas and crystallise one's thoughts; it is very annoying to have a brilliant idea which can be so fleeting that if it is not caught, may vanish, never to be recalled.

We all have our preferences with regard to subject matter and as we pursue our own interests we discover unusual sources of inspiration. Never be afraid to ask people for help or permission to further your researches – most people are interested or flattered to be of assistance.

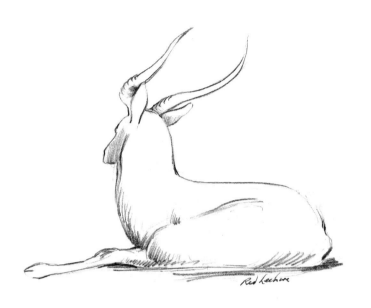

Red Lechwe

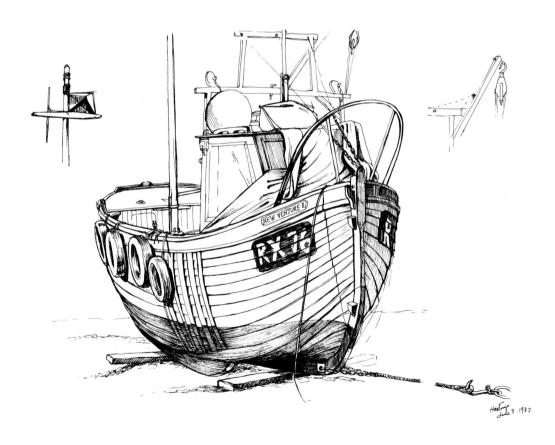

NEW VENTURE II

RX 16

Hastings
June 3 1983

28

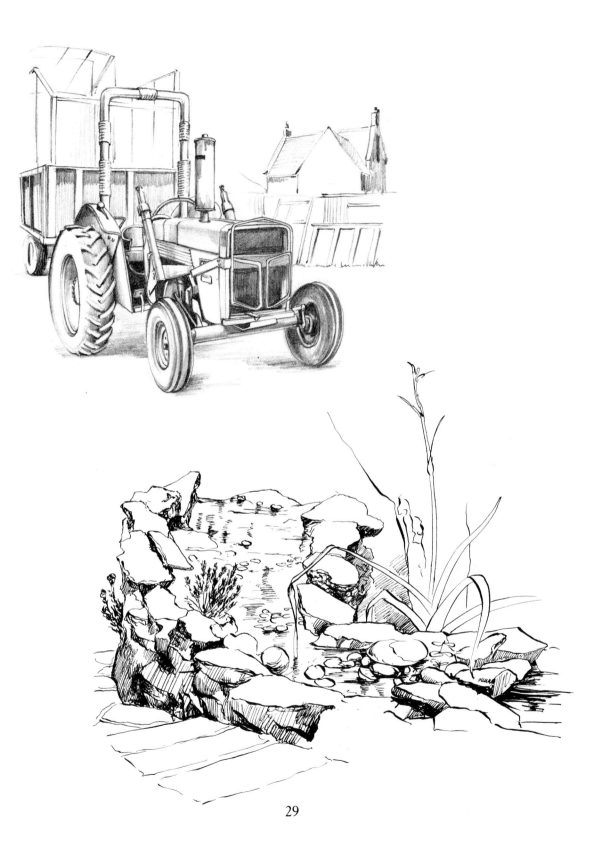

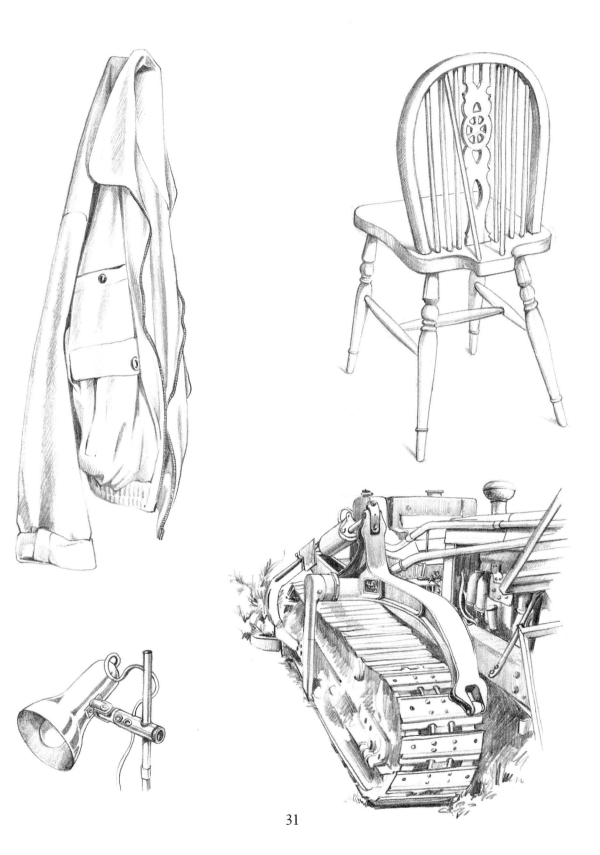

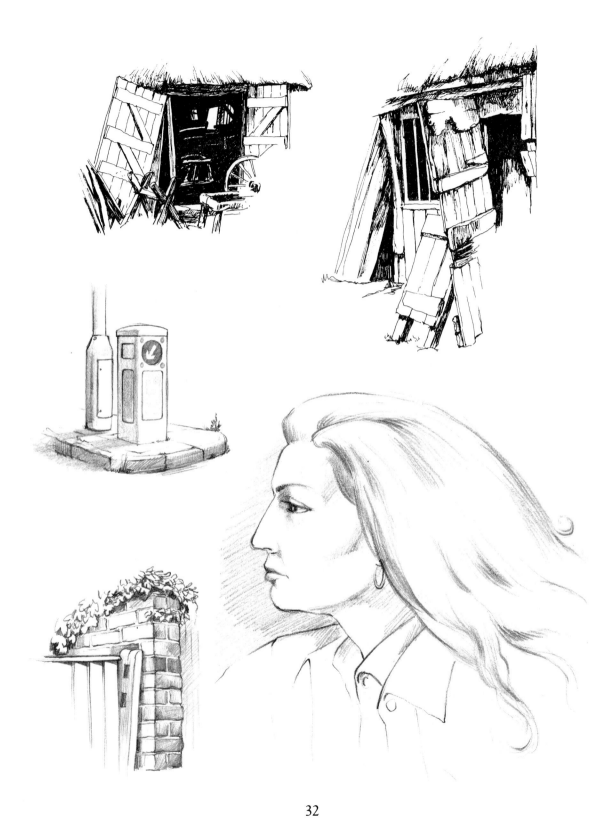

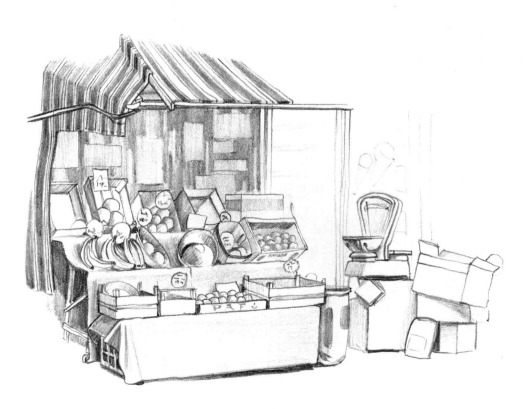

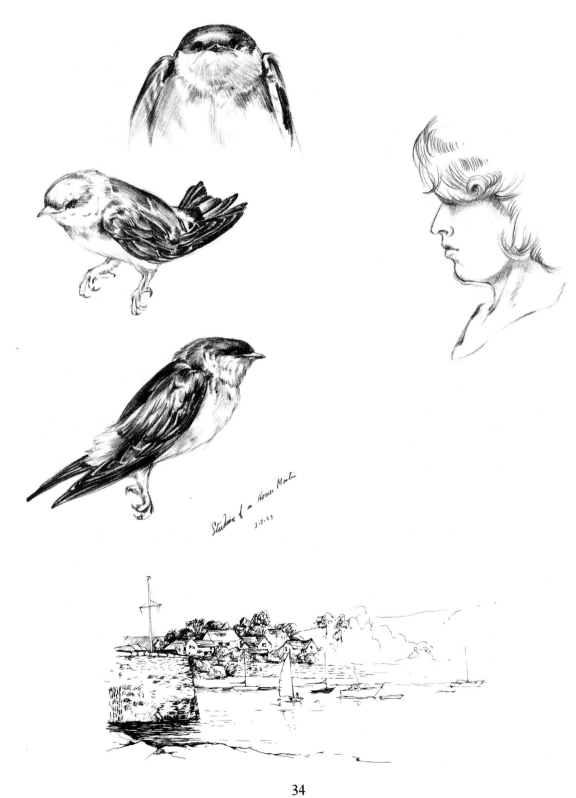

Studies of a House Martin
3.7.53

34

Photographs

This is a fascinating exercise because we have the real creature, 'frozen' as it were, for us to study at leisure. There are many wonderful books full of superb photographs and most local libraries are stocked with fine collections of reference. If you are a skilled photographer, you have at your command a ready 'collection of information' device. Careful copying of photographs can be most helpful. One has the opportunity to study closely many details which may be denied to you when drawing the real thing. One word of warning, beware of getting 'hooked' on drawing in this manner, remember that there is *nothing* better than drawing from life.

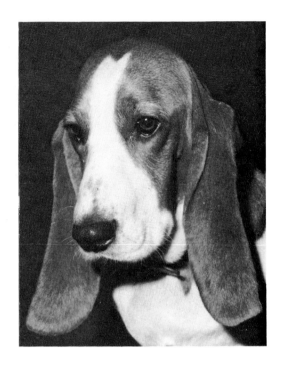

'Happy' the basset hound

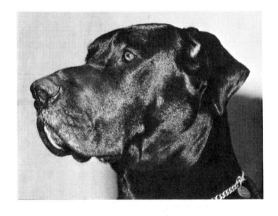

'Angus' the great dane

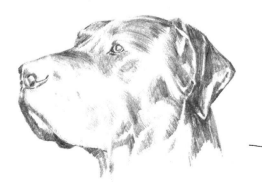

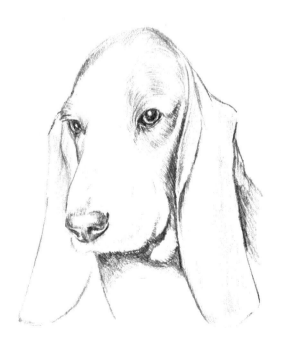

36

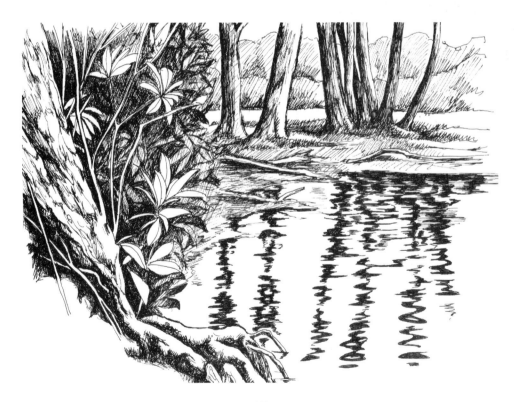

Animals

The animal kindgom has always been a source of wonder and inspiration for the artist and many of us have had a cat or dog as a companion in childhood.

It is easy enough to draw a creature when it is asleep but moving about is a different matter altogether. As with any subject let us take it one step at a time.

First of all start by looking very carefully at the chosen subject, studying its shape and movements. A cat for example, has a smooth, soft, sinuous motion whereas a camel plods along with a characteristic proud and haughty lift to its head and neck.

It is useful if possible to have some knowledge of the anatomy of the animal so that the drawing has an authentic appearance, especially where the muscles can be seen moving under the surface of short-furred animals (see the skeleton and muscle layout of the cat page 39).

Having studied the chosen animal, start by drawing the most important movement lines. If you are drawing a cow in a field or an elephant or tiger in a zoo, you may have to follow it around. Cover as many pieces of paper as you like until you are satisfied that you are well acquainted with the animal.

Having achieved the general outline and character, start to analyse each part, a paw or hoof, an ear or an eye, and then gradually assemble these details onto the basic outline you have already drawn. You will soon find the picture emerging. Look at the light and shade and start to add some tone to the drawing. This will give it an appearance of solidity.

Following this, some indications of the fur covering and any special markings may be added. A word of warning here: do not try to draw every piece of fur or body covering. If you do, the look will be static and boring. All you need is a general indication to give an impression. Remember that if you want that intricate kind of detail you can more easily take a photograph.

Lastly, it may be necessary to add specific markings as in drawing a zebra or a leopard, but again do not overdo it. A glance at the illustrated examples may help.

When drawing a portrait of an animal it is permissible to give more attention to details. The page devoted to the drawing of fur will be of assistance (page 43).

It is a good idea to use photographs at some stage to familiarise yourself with details so that you will more easily recognise specific features when confronted with the real thing (page 41).

Finally do make studies of eyes particularly when doing animal portraiture – the drawing is dead without the luminous mirror-like eyes (page 45).

Anatomy of animals

Many animals have short fur (the big cats, for example) and much of the muscle structure can be seen in action. It is advisable, therefore, to have a basic knowledge so that silly mistakes may be avoided. Study the drawings on these pages which attempt to give common points to look for.

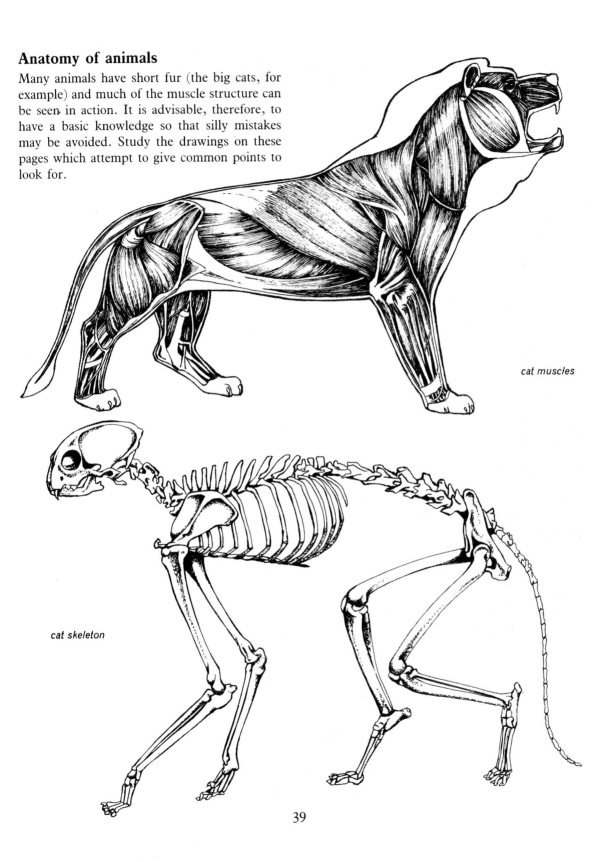

cat muscles

cat skeleton

39

Movement

Drawing moving animals is not so difficult as you may imagine. The first thing to do, as always is to stand and stare. Observe how the animal moves. The illustrations of the bears (opposite), is a good example made at the zoo. In these circumstances, the animal is restricted and usually establishes a pattern of exercise for itself. The pattern of movement is what we are looking for.

This bear spent a good half hour or so pacing up and down his enclosure with only minor variations every now and then, plus a few pauses. It will be noted that I have drawn the animal coming towards me as well as going away. This meant I could get two bites of the cherry and did not waste any time; also I could fully observe the bear all the way round.

A few well considered lines was all that was necessary at first (1); this stage gave me the general pose and the character of the bear. Stage two (2) started to give me the main bulk, light and shade, 3 shows the finishing off stage and it will be seen that I tried two slightly different techniques of drawing the fur to see which looked best. The illustration of the bear going away from me I feel is a little harsh in treatment, but the picture of him coming towards me is softer in the application of the pencil. I feel it gives a better impression of the soft fur as well as giving the feeling of enormous strength and bulk of muscle underneath.

Never be afraid to experiment, you will always be able to improve your drawings by doing so.

The page from my sketch book of penguins was illustrated in the same way as the bears. Selecting a position which I wanted by observing the pattern of movement of the bird and waiting for it to come round again so that a few more lines may be added. These drawings will be used at a later date to make authentic looking pictures.

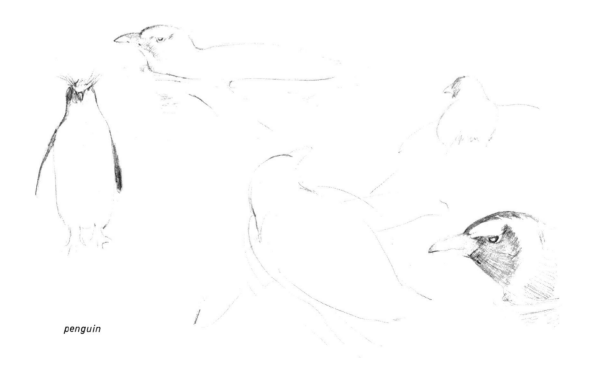

penguin

40

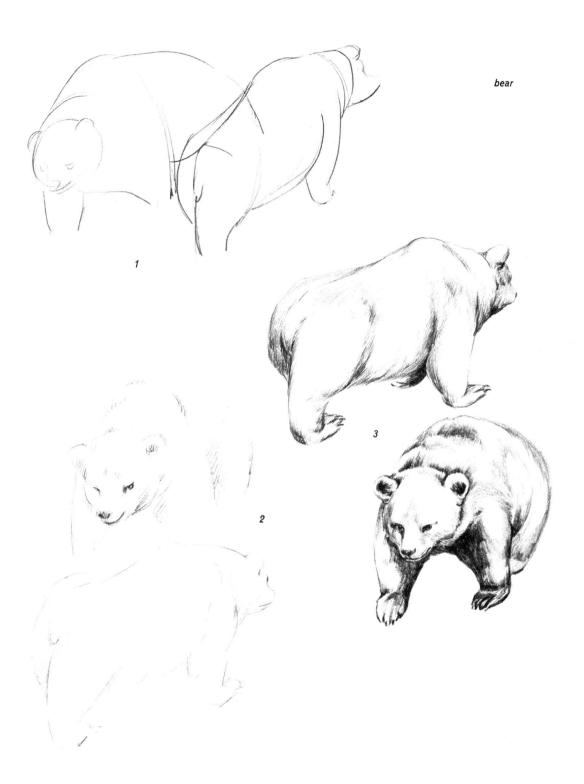

bear

1

2

3

41

Line drawing

This method of drawing is very useful for quick sketches and notes and for capturing the image of movement. It is obvious that very little detail can be obtained by drawing a creature at speed and by using pure line, the main general lines of movement can be put down. These can always be augmented later. There are animals which by their very clean and sleek appearance, demand the use of this technique to obtain a good likeness.

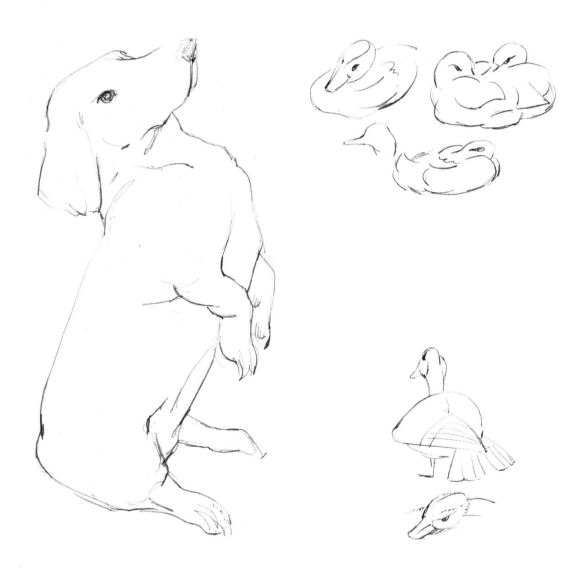

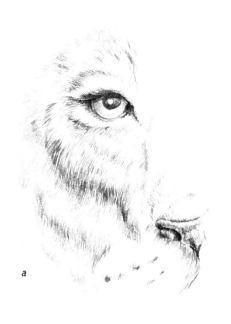

a

Drawing fur

There are many types of fur or hair, some short and some long, some soft and some hard and sometimes a combination of several kinds on the same creature. It is our task to show all these so that the drawing can be easily recognised and look authentic.

For short, soft fur it is necessary to build up a series of short, soft pencil strokes in the correct direction making them darker in shadow and becoming lighter in touch as the form turns towards the light source a). Not only does this give the desired soft fur look, but it gives the drawing the solidity and form which is essential.

Long hair b) can be indicated in mass in the first instance and then shadows and darker portions added c) to emphasise masses of hair. It is very important to follow always the direction of the fur, particularly when there are folds of flesh underneath.

Colour and markings can be added on top of the basic fur or hair drawing and this is obviously necessary for animals with distinctive markings e) and f). One cannot imagine a tiger without stripes or a leopard without spots.

Do not forget to vary the intensity of the pencil strokes, otherwise a lifeless and wooden drawing will result.

b

c

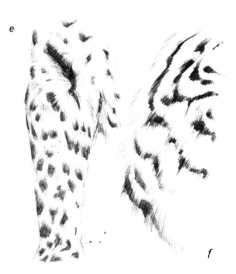

e

f

43

The character of the animal

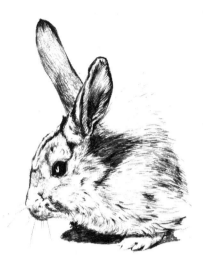

rabbit

The added warning of impending attack is that of any cat, the rising of the fur, particularly around the head. All these details help to produce a convincing portrait of this complex creature.

Even when drawing a predator at rest or asleep, one can still give the impression of power, grace and even fear by accentuating characteristics such as stripes and heavy, little and powerful muscles which are easily detected under the fur.

There are excellent natural history programmes on television these days when animals can be observed at leisure or slow motion. It is always advisable to keep a sketch book handy, ready to jot down sketches immediately, corrections can come later and it is found that the first quick strokes of the pencil are usually correct.

As illustrated, a rabbit is a hunted, docile and very vulnerable little beast, its large ears are continuously twitching to catch the slightest sound of danger. Its large, ever-aware eyes are always alert—one sound or sight undetected could mean its life. Also, the large, powerful hind legs instantly ready for escape from danger.

The fact that rabbits breed so profusely must be some indication that perhaps its defences are not adequate against all its predators—particularly humans—and therefore need to replenish its own kind so rapidly.

The tiger, on the other hand, has few enemies, partly because, with such weight, speed and strength, few animals would wish to tangle with it. Also, with its massive teeth and sharp claws it is easy to focus a drawing on these details to emphasise its ferocity. Even when the tiger is just giving a warning growl, note how the light in its eye changes to an extra brilliance, also the wrinkling of its nose and upper lip which make the whiskers stand on end.

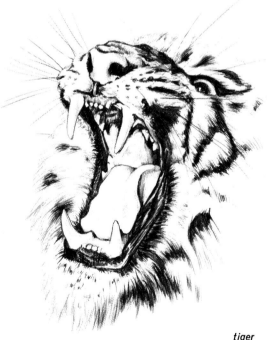

tiger

44

Eyes

Have you ever really looked at the eyes of a bird or animal? It seems to me that they mirror the character of the creature. The piercing eye of an eagle or hawk sparkles with voracity, the lion or tiger have a haughty uncompromising aspect—sometimes lazy and half hooded with a benign apparent sleepiness, but just as quickly almost brilliant red with rage. Animals and birds of prey can be identified by the eyes alone, such is the assurance of supremecy reflected from them.

Creatures which are preyed upon,, such as deer, rabbits, sparrows, mice and ducks usually have large open sparkling eyes, ever alert, but with a softness which denotes an apparent docility and gentleness.

These characteristics are essential in animal and bird portraiture to capture a convincing essence of the creature we wish to portray. Very close studies of our chosen subject is necessary from life, whereever possible, as well as from photographs. There are many beautiful books available with magnificent studies, which give us much of what we need for close examination of construction—not only of the eye itself, but of its surrounding eyelashes, brows, etc. in all their different forms.

You have only to imagine your drawing with the eyes blanked out, like an ancient marble bust, in fact you can try it. Cut out a piece or pieces of paper to correspond with the shape of the eyes on your drawing or photograph and by placing them in the correct positions over the eyes you will immediately be aware of the creature without life, take away the blanks and it springs into being.

By this illustration we can see how essential our attention to detail must be with regard to eyes if we are to control the life—like quality of our drawings. One other point of interest is the careful observation of reflections and highlights in the eyes as well as the various flecks of pattern sometimes surrounding the centre. Also, where appropriate the shadows cast by the brows, lashes or hair. Study the various illustrations and then observe from your own experience the differences which make up the particular character of your chosen subject.

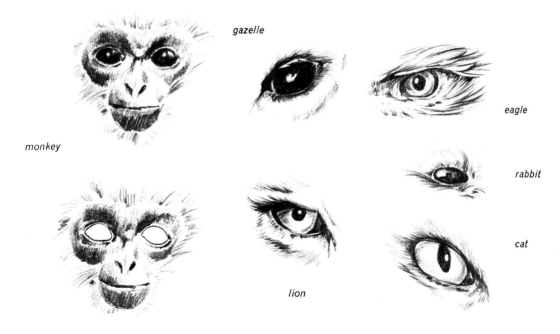

gazelle

eagle

monkey

rabbit

cat

lion

45

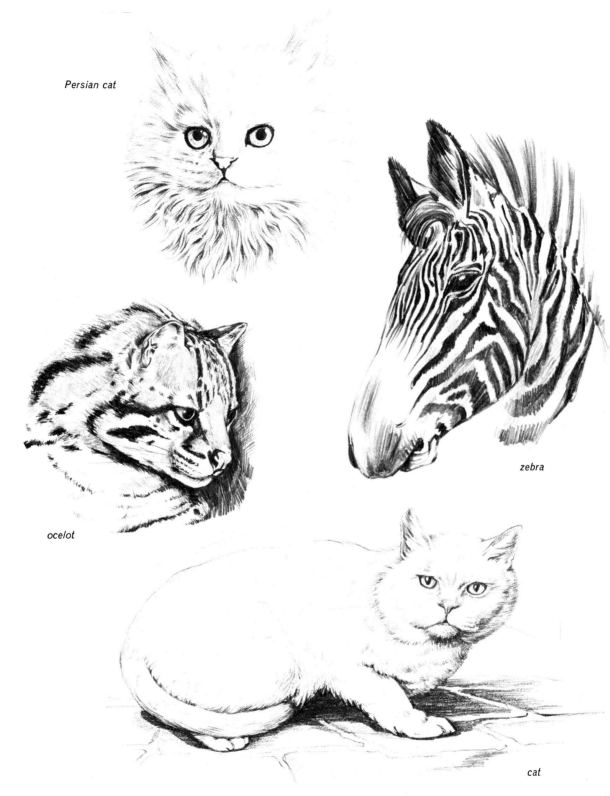

Persian cat

ocelot

zebra

cat

46

Birds

At first the bird members of the animal kingdom appear almost impossible to draw, since for most of the time they are hopping around with quick, jerky movements, or actually flying, which means that they are only visible for a moment or two. In the following pages attention has been given to specific aspects of drawing birds which may be found helpful, but to allay the initial fears that 'this is beyond me' let me re-iterate the general approach.

Given that there is a desire to draw something which we can see, then it can be done. The drawing starts with the 'will' to do it, then comes the 'looking', as the brain starts the 'logical sorting out procedure'. You will note that we have not as yet suggested picking up a pencil. Remembering that we wish to eliminate anything which intrudes between the eye and the object we wish to draw, we must only analyse the things which we need and ignore or discard those which are distractions.

Observations and quick sketches to familiarise ourselves with the subject are the next stage. Always be prepared to make dozens of sketches and if necessary throw them away. If they contain no real lasting value, they will only be a clutter and in any case remember that all the information you gather is stored in your own personal computer, your brain, so nothing is wasted – it is merely waiting to be recalled.

Gradually you will find that as you become familiar with your subject you automatically start firming up on the idea for your final drawing.

Now you have your shape, movement, and composition worked out, and you can enjoy the details of light, shade, feathers, markings etc.

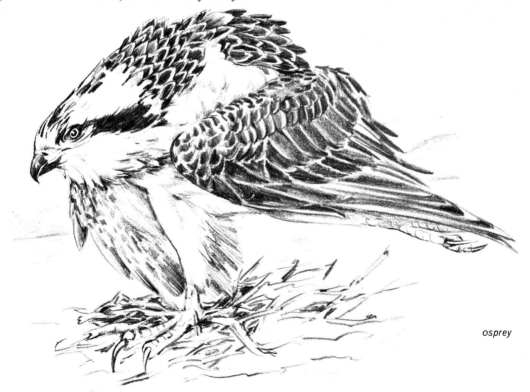

osprey

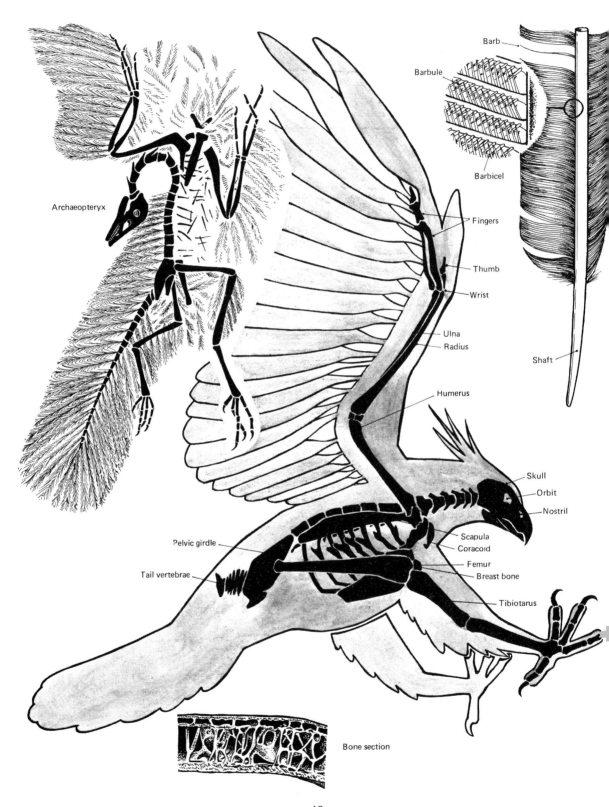

Barb

Barbule

Barbicel

Archaeopteryx

Fingers

Thumb

Wrist

Ulna
Radius

Shaft

Humerus

Skull
Orbit
Nostril

Pelvic girdle

Scapula
Coracoid
Femur
Breast bone

Tail vertebrae

Tibiotarus

Bone section

48

The character of the bird

It is important to first attain the typical shape and stance of the chosen species; if this is not convincing, no amount of careful drawing will make the bird look correct. Take for example the Tit family. As shown in (1) below it is a sprightly, acrobatic little bird who hangs upside down. This must be initially sketched in before proceeding with any details. The eagles and hawks must be shown to be fierce and comparatively heavy predators.

It is obviously necessary to study your subjects well before attempting to draw them; to know their habits and mannerisms, also their habitats, thereby illustrating from sound knowledge rather than by chance.

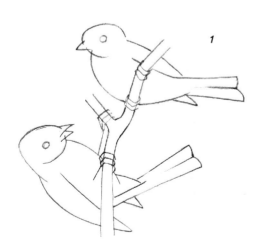

1

2

Flight

Many of the action pictures we may wish to draw will be inevitably of birds in flight.

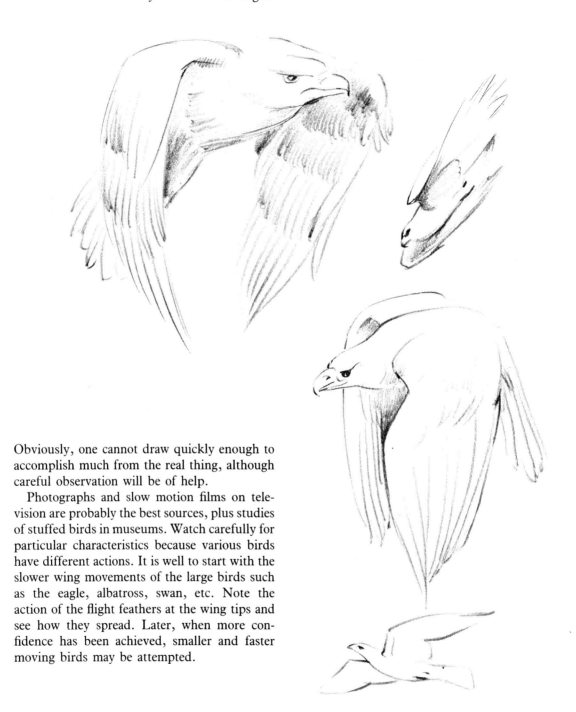

Obviously, one cannot draw quickly enough to accomplish much from the real thing, although careful observation will be of help.

Photographs and slow motion films on television are probably the best sources, plus studies of stuffed birds in museums. Watch carefully for particular characteristics because various birds have different actions. It is well to start with the slower wing movements of the large birds such as the eagle, albatross, swan, etc. Note the action of the flight feathers at the wing tips and see how they spread. Later, when more confidence has been achieved, smaller and faster moving birds may be attempted.

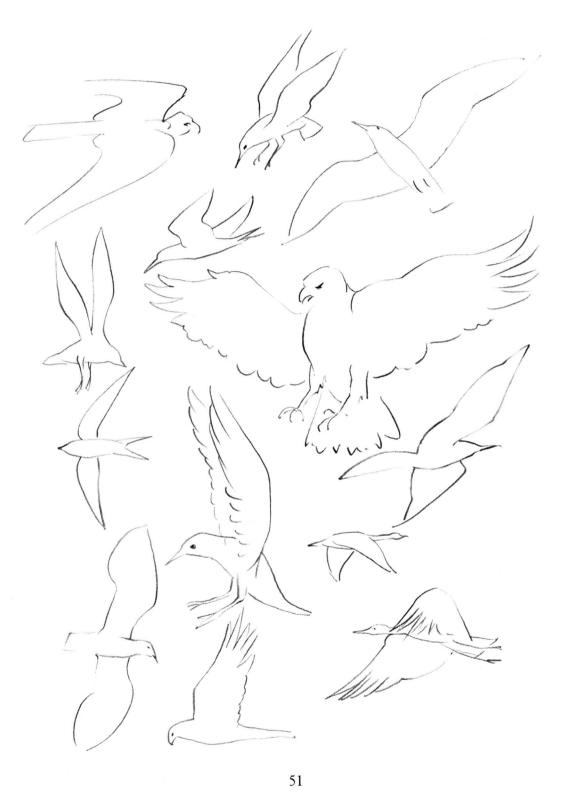

Drawing feathers

When drawing feathers, do not be dismayed by the sheer quantity on each bird. They have, of course, hundreds covering them and we must somehow give that impression. As always, it is a matter of selection, but for a finished drawing there is no short cut and many individual feathers have to be drawn.

There are usually areas where the feathers are small and soft and these must be indicated only and not over emphasised, otherwise they will appear too hard and important. One must imagine what it would feel like to run ones hand over the soft parts and try to emulate this feeling by the softness of the pencil strokes. On the larger wing, flight and tail feathers, there must be strength and rigidity therefore we can put in bold, well defined lines which act as a contrast to the soft ones and incidentally adding interest to the drawing.

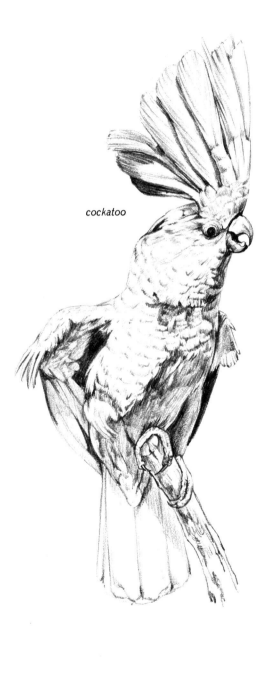

cockatoo

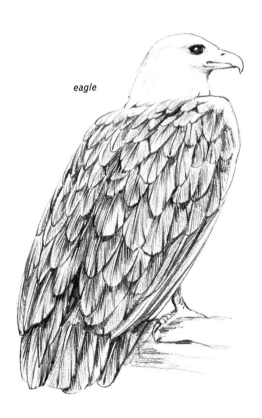

eagle

52

Look at the basic foundation of drawing (a). Once this is established a soft pencil can be used to soften the feathers together (b). After this, any markings peculiar to the bird may be added, these should be evident, but not over 'hard'. At the same time, general shadows can be added to help give 'form' (c).

For the larger, harder feathers, work out the basic silhouette and the correct placing and arrangement (d); then note how the barbs are indicated and how the shaft is drawn. Many feathers become ruffled and the barbs break away from each other, so it is useful to draw one or two of these. Beware of being carried away with this detail, otherwise your bird will look as though it is going to fall apart!

Shadows between feathers are very important. Not only can they be used to unify the whole drawing, but also to separate the feathers so that they can easily be seen. Finally, darker tones can be added where necessary when special markings need to show the species of bird you are drawing.

It is as well to practice groups and individual feathers and their formation before tackling a full scale drawing. On this page are some individual feathers of specific species which can be used as practice points.

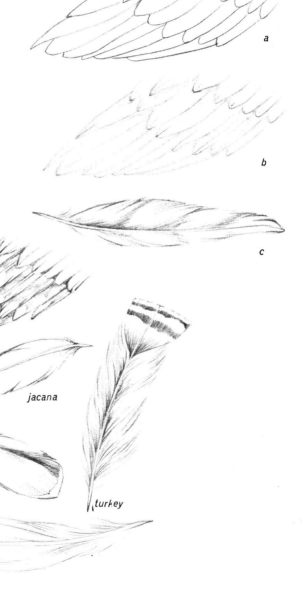

a

b

c

grouse

jacana

mallard

turkey

flamingo

53

Habitats and surroundings

It may seem an obvious thing to state that to make our pictures convincing, we have to consider the appropriate backgrounds. Yet silly mistakes can be made at times and it is sometimes helpful to spell it out.

It would be unusual to say the least to visualise on eagle with a background of a housing estate instead of against its usual mountain vastness. Or a giraffe in your local supermarket, instead of in a zoo or on its native terrain.

To know your creature is to portray it with conviction. For example, it would lay one open to criticism to draw an African elephant in the trappings of an Indian elephant.

So that all occasions can be covered and to be able to draw convincing backgrounds, it is necessary to practise such details as trees, water, flowers, rocks, houses, brick and stone walls, in fact anything will be useful sooner or later. Some suggestions for details are illustrated in this section.

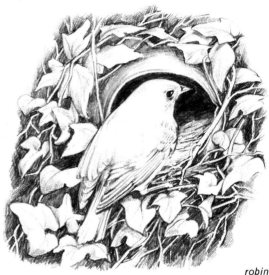

robin

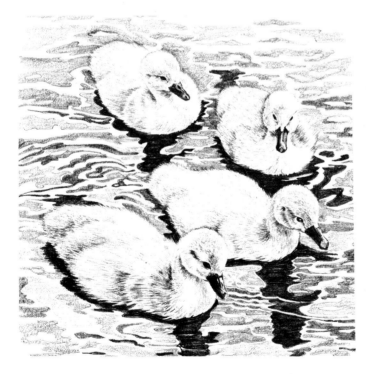

cygnets

54

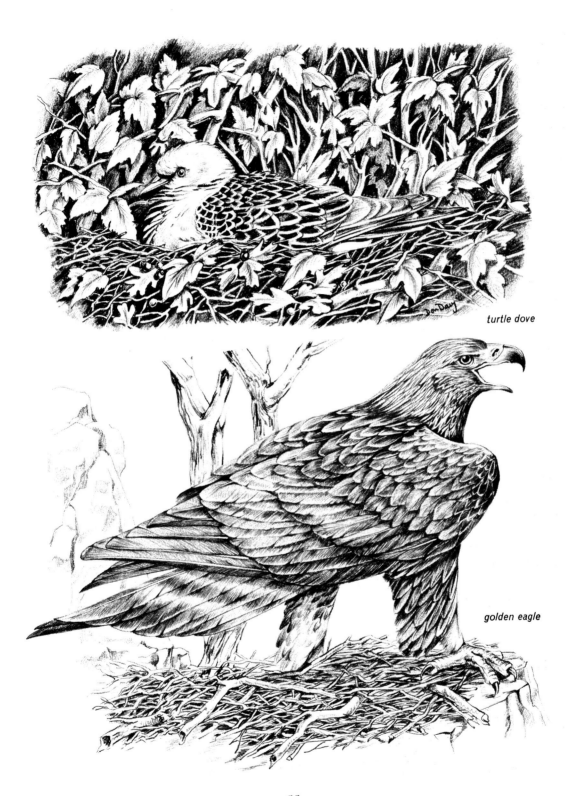

turtle dove

golden eagle

Water and Reflections

Water has its own peculiarities, and a particularly annoying habit of continually moving. It is therefore necessary to approach it in a very logical manner. Let us start with a small pool or pond of water which is comparatively still and has some reflections. This may be likened to a mirror (Figs. I & II).

The clarity of the image depends largely upon the colour of the water. As a mirror needs a dark silvered backing to make it reflective, so water requires a dark density to bounce the image off its surface.

In Fig. III the water surface is disturbed and starts to move. This illustration shows the beginnings of a distortion of the original image. With the further disturbance of the water the image is almost totally destroyed and becomes unrecognisable (Fig. IV) but the water still has a reflective look.

The perspective of reflections on water-surfaces plays an important role in making our reflections look authentic. To convey this concept in visual terms, the further an object is from the eye the clearer the reflection on a disturbed water surface, whereas the nearer the object to the eye the more fragmented the relected image becomes on the broken water surface.

In Fig. V it will be noted that the wavelets in the distance are closer together and that the fragmentation of the image, which touches the top of each wavelet, therefore shows a more solid reflection. As the wavelets in the middle distance and foreground are nearer to the eye one can see the troughs between the wavelets becoming larger. These non-reflective areas break up the image between the wave tops and fragment the image until it disappears and becomes unrecognisable.

This fragmentation is one of the things that make water look wet and objects upon it appear to move. With water movement, a lot can be learned by studying still photographs and also by careful watching of one small patch of water to observe the regularity of the pattern it makes (page 37). There are many factors governing the movement but there is bound to be repetition. Only a few rules apply in drawing water movement.

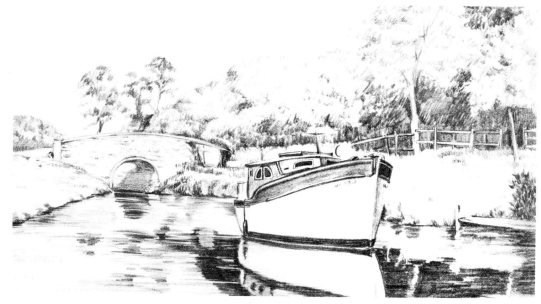

Fig. I

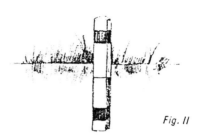

Fig. II

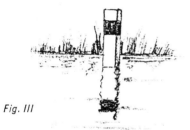

Fig. III

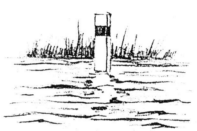

Fig. IV

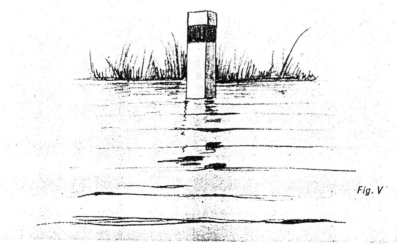

Fig. V

The illustration of a one-stage waterfall will help in the understanding of some of the details involved. It reveals that the main body of water of the river appears to be still and calm up to the edge of the water drop. Although this picture was drawn during a flood the only appearance of rushing water is when it actually curves over into the lower level, creating turbulence. This effect is achieved by drawing the higher level of water with firm, clearly-defined reflections, also clear light and shade on the heavy weight of water dropping, and then changing the technique to show soft, frothy light and shade patterns.

The stillness of the water surface on a slow-moving river is comparatively easy to depict; it basically depends on the lines and shadows of reflections being drawn horizontally – and the more light and shade there is, the better the simulation of a glass-like reflective surface.

Creating further illusions of reflections can be achieved by adding details associated with water such as bridges, piers, locks, boats, etc.

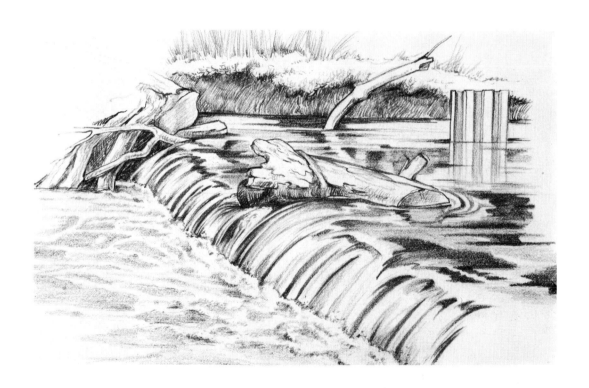

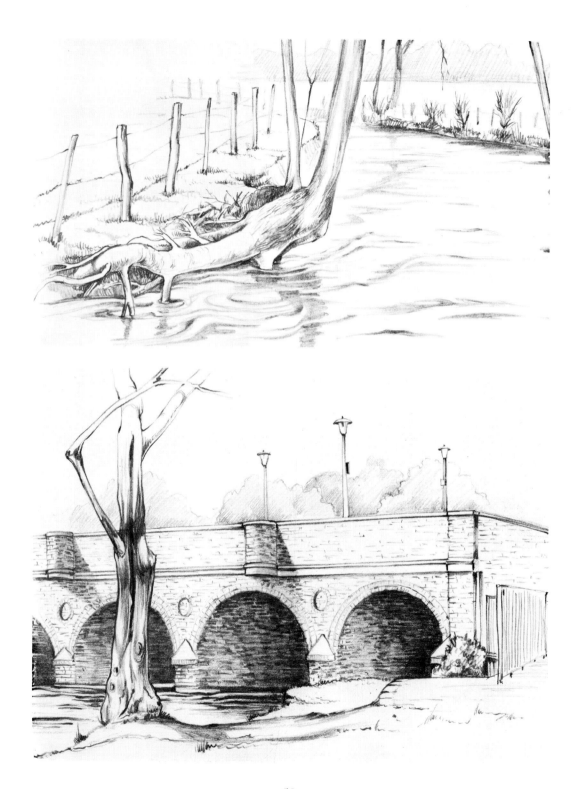

Waterfalls

Waterfalls have a magic of their own. I would only recommend giants such as Niagara or Victoria Falls to those who have a fair degree of practice, but study of complex small falls can give all the details needed and are easier to do at

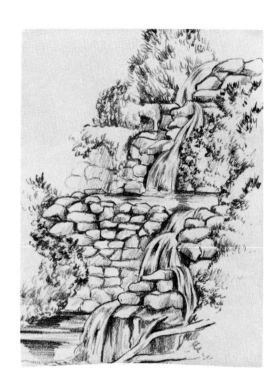

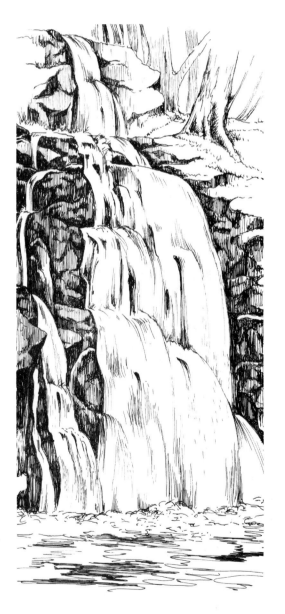

close range. The drawings shown here are of the same waterfall from different angles, one in winter in spate, the other during a hot summer.

It will be noticed that the surrounding vegetation is more evident in the summer study and non-existent in the winter one. When there is an abundance of water a lot of details are smoothed out and water literally appears as a sheet and can be drawn as such. The force of falling water can also be described by the bubbling movement at the base of the waterfall as the water crashes into the pool below.

Interest can always be found in the immediate surroundings such as rocks, trees, roots, bushes, etc., and these add to the authenticity of the study. Drawing the water on its own may not give the same impression.

60

Sky and Clouds

Considerable dramatic effects can be achieved by the use of clouds and dark skies in your pictures. The obvious example is a black glowering sky full of rain clouds in a storm at sea; the character and atmosphere of the picture is immediately created.

The other use to which clouds can be put is as an object to be reflected, which has been mentioned before. The object does not necessarily have to be solid, the dark areas of clouds are quite sufficient to give a reflective substance on water or waves. The examples of the use of clouds in this section will give an idea of the completeness of a picture and the creation of an atmosphere.

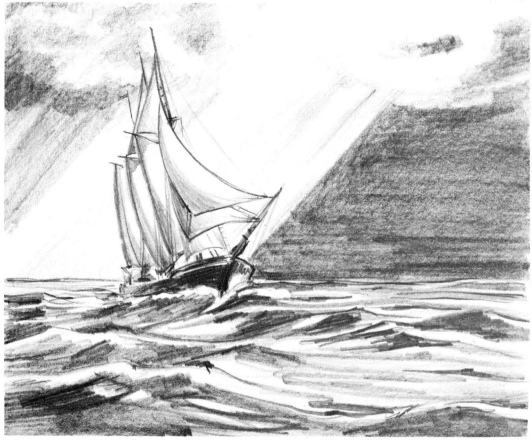

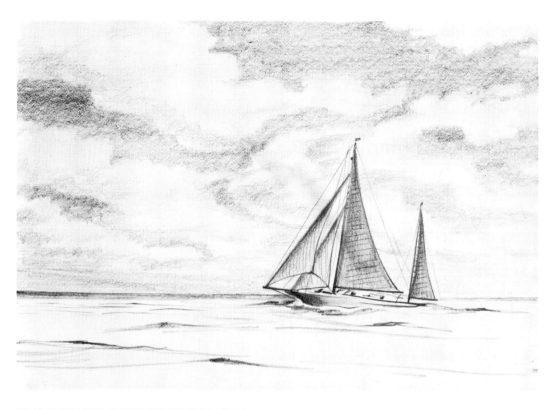

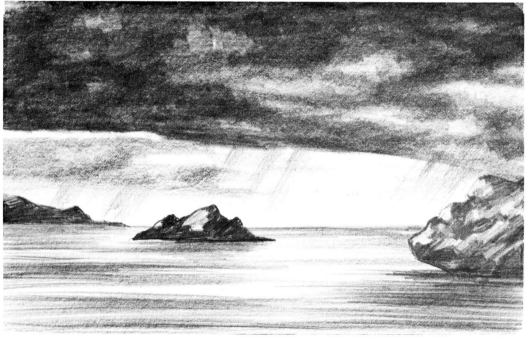

Boats

For various reasons man has always had a fascination for boats of all kinds, from rowing boats to the great majestic ocean-going liners. Perhaps there is a latent desire for the excitement of travelling to far-off romantic places and experiencing the thrill of a small element of danger. Whatever it is, we are drawn as if by a magnet to look at, and hopefully to portray boats, ships, water, and all their paraphernalia.

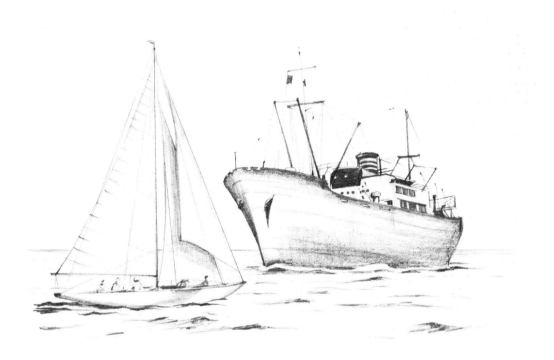

Selection of Site

There are many places where we can sit and work without bothering other people, but there may be times when you wish to actually board a boat or enter a boatyard or wharf or even go into a field which has an adjacent river. It may then under these circumstances be necessary to ask permission to enter or use this property. Care must always be taken not to abuse these privileges otherwise owners may be antagonised and deny facilities to other artists in the future. Do not forget at all times to use common sense.

'Cutty Sark', Greenwich, London

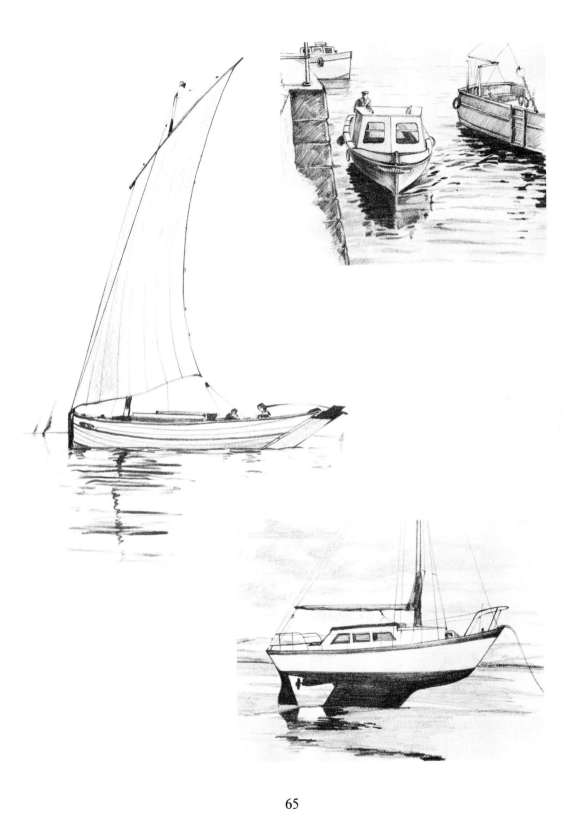

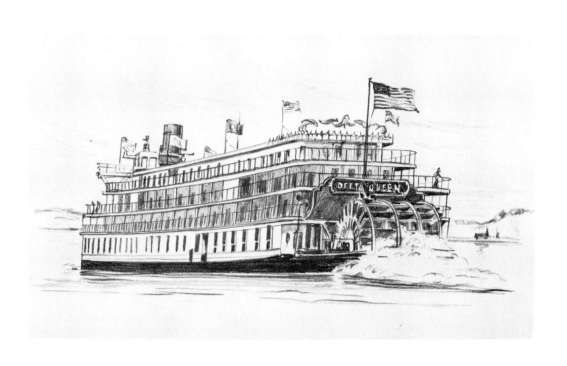

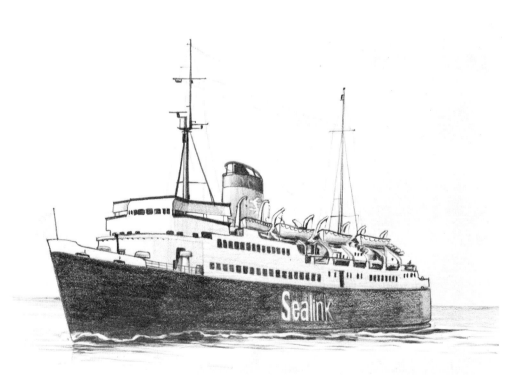

Buildings

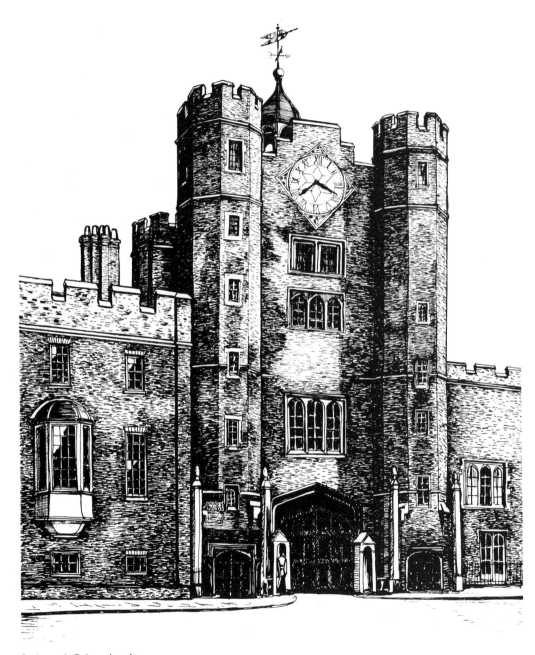

St James's Palace, London.

Basic Construction

Buildings in their simplest form are merely a series of geometric shapes: cubes and cones, spheres interlaced with squares, oblongs, triangles and circles. As they are solid objects we have to express them by obeying the rules of perspective (pages 21–23).

The easiest drawing to be made of any building is the flat elevation because little or no perspective is involved. By using a very simple and direct technique such a drawing can be very attractive. As long as the proportion and dimensions are correct, it is merely a case of putting all the details in the right places and the drawing emerges. Such a drawing rarely shows any real solidity; it has the appearance of a flat illustration or diagram, rather than having a three dimensional interest which is created by using perspective to supply the illusion of depth.

By using an angled view point, a feeling of 'going into the picture' is created as well as the sense that one expects to know what is around the sides of the building. In this way there begins to be a completeness, a solidity.

Phillips House, Dinton, Wiltshire, England.

The building selected to be drawn should be stripped in the mind's eye of all its trappings of detail and decoration. It is then reduced to its basic form which is sometimes merely a simple box surmounted by a prism shape. Having established these simple shapes in the correct perspective, all the details may then be applied. There is nothing more annoying than to spend an enormous amount of time on a detailed drawing only to find that the basic shape, or perspective, is wrong and the whole picture is ruined.

69

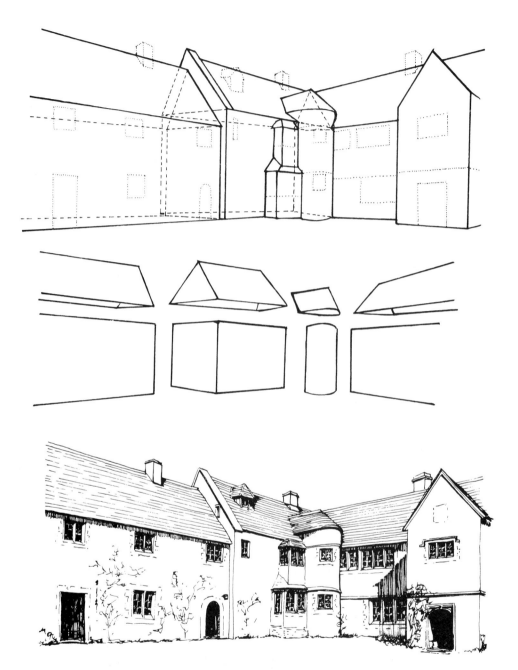

Westwood Manor, Wiltshire, England.

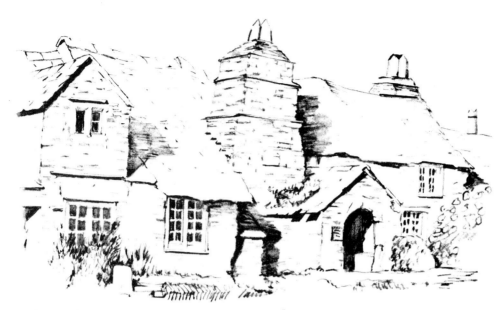

The Old Post Office, Tintagel, Cornwall, England.

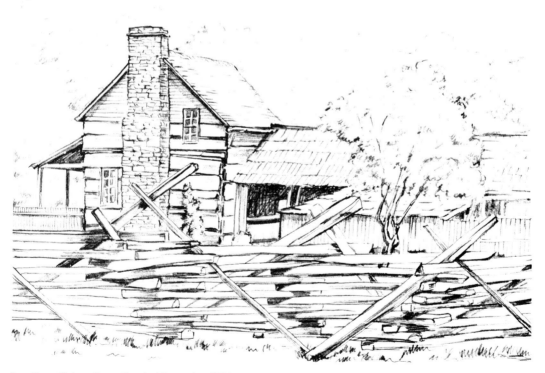

Log Farm House, Great Smoky Mountains, USA.

71

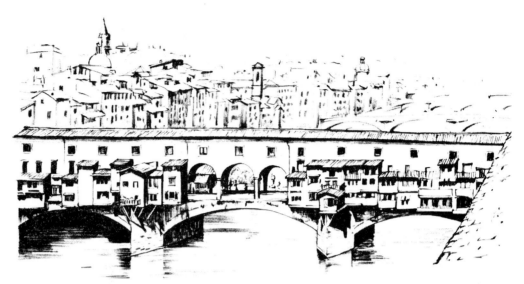

Ponte Vecchio, Florence.

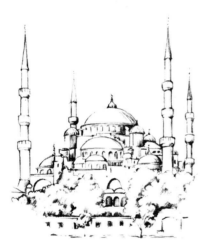

Santa Sophia, Turkey.

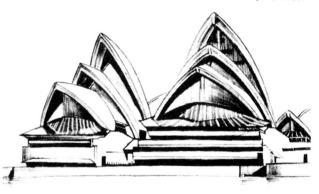

The Opera House, Sydney, NSW.

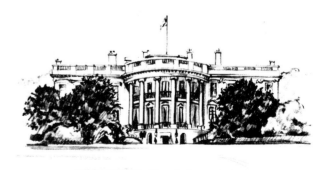

The White House, Washington.

72

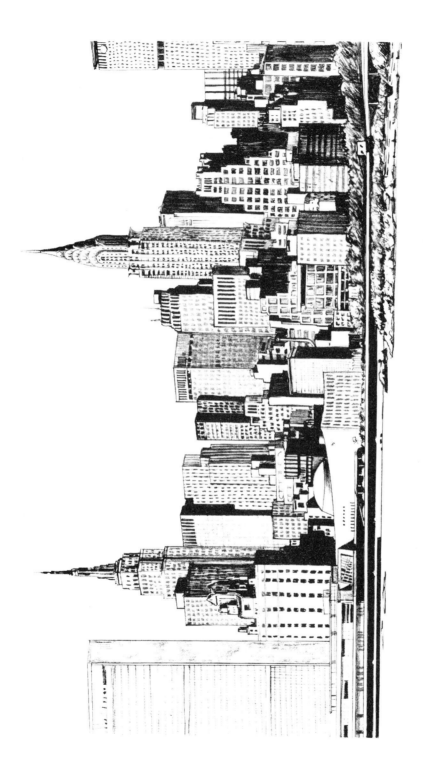

New York Skyline.

73

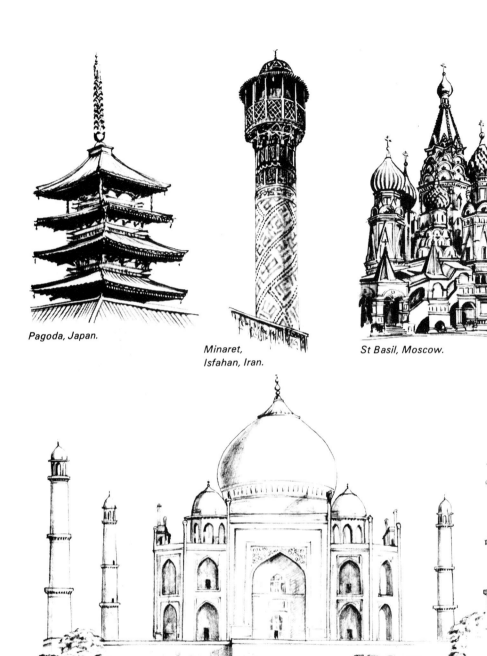

Pagoda, Japan.

Minaret,
Isfahan, Iran.

St Basil, Moscow.

Taj Mahal, India.

Polperro 1979

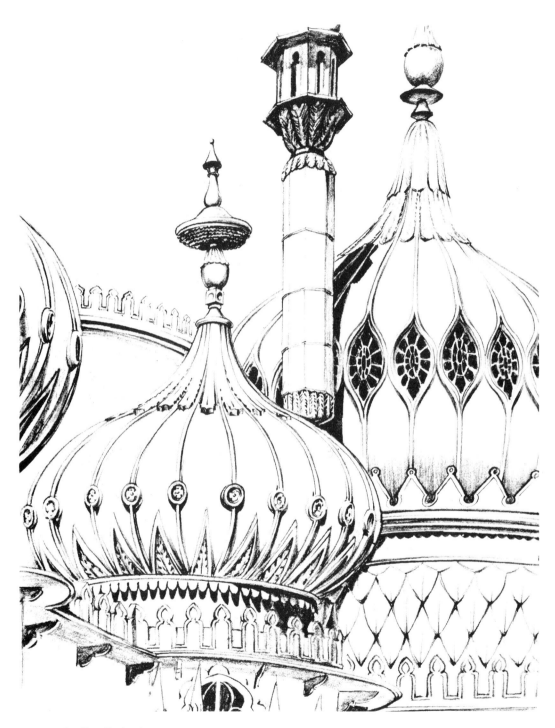

Brighton Pavilion, England.

Wall Fountain, Bramham Park, Yorkshire, England.

Museum Entrance, Valencia, Spain.

Sanctuary Knocker, Durham Cathedral, England.

Balustrade at Charlecote, Stratford, England.

Transport

One can approach the drawing of objects such as cars, trains and aeroplanes in exactly the same way as anything else which we have already studied. The rules of perspective apply in just the same way as drawing a building or box. Trains, etc. provide good opportunity to use perspective to dramatise your drawing.

Remember to use a lower horizon to make the image appear larger and grander (see fig. 1).

Once the basic drawing has been established, various techniques can be used, some to indicate speed (see fig. 2), and others to depict shiny surfaces (see pages 80, 81, 82, 83).

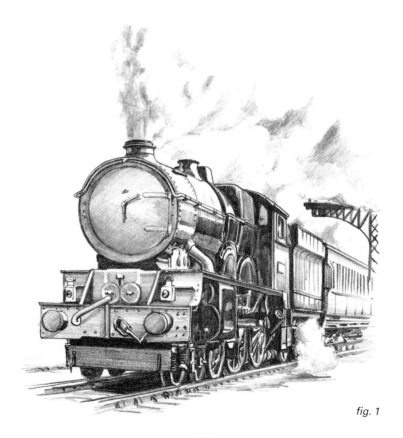

fig. 1

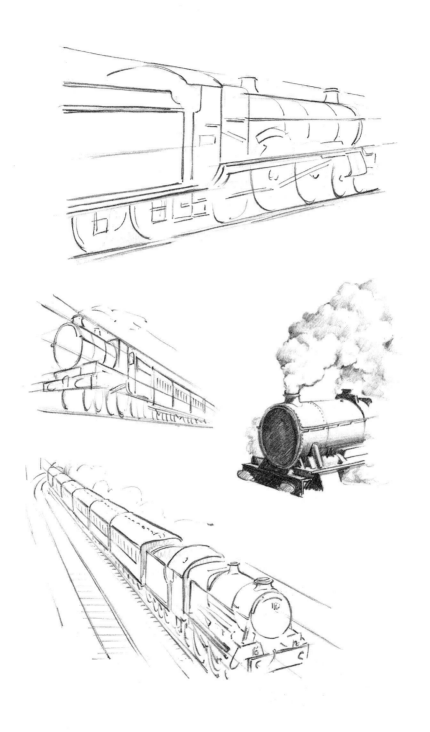

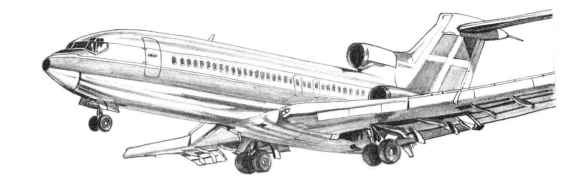

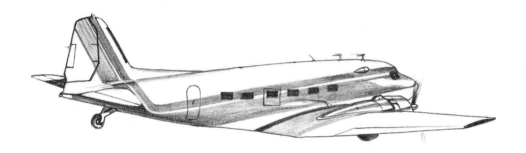

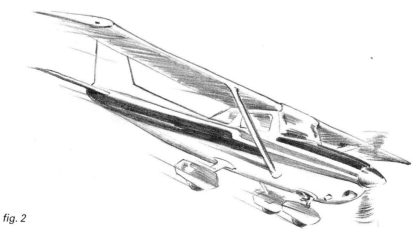

fig. 2

80

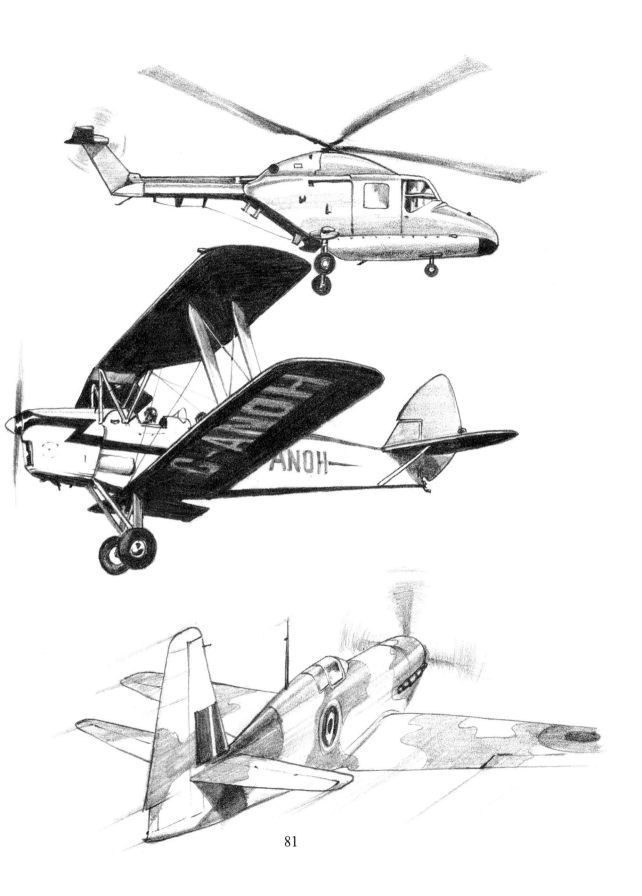

81

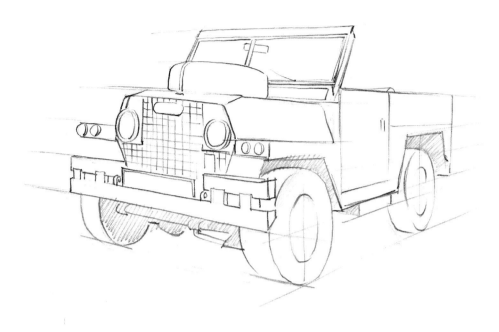

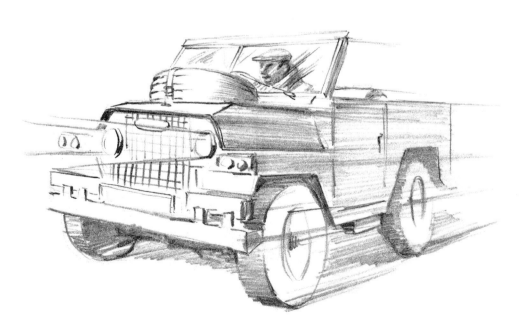

82

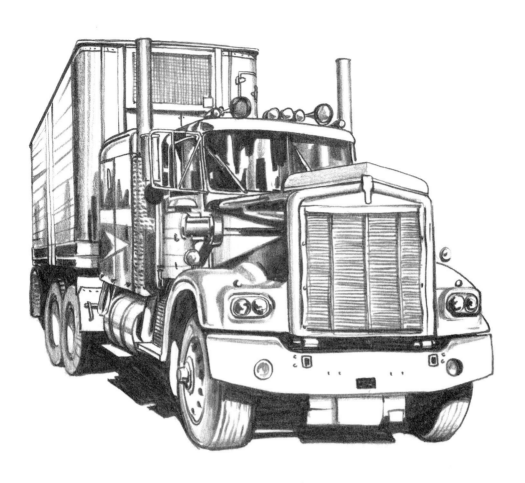

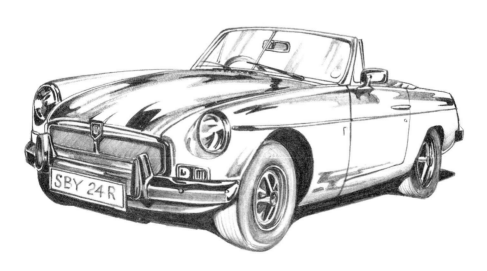

SBY 24 R

Trees

Trees have their own distinctive shapes and there is as much difference between a cyprus and a yew as there is between a lion and a giraffe. For this reason, something more than a cursory study is required (for examples see page 87).

It is well to start from the trunk and branches and then proceed to dress them in foliage. Try to imagine the tree as a whole from the roots upwards (fig. 1). Look at the various types of trunks and the angularity of the branches followed by the detail of the twigs. Wintertime is obviously the best season to study these.

Note at the same time how the various species differ from each other, for example the elm and the oak.

When observing trees in their summer dress it will be noted that what at first appears to be a disorganised mass of foliage actually has a structure of lumps and groups of leaves. These in turn can easily be seen in heavy light because the shadows which are cast give the whole mass a solidity (fig. 2).

Having constructed the trunk and sketched in the position of the branches, indications of the foliage may be added. Once the light source has been established some shadows can be blocked in to give a three-dimensional image. When adding the leaves there is no need to attempt to draw every individual leaf – this would not only drive you mad, but the ensuing result would look lifeless and stilted.

Look at the illustration (fig. 3) to see how marks can be made to indicate leaves and increase the density of the shadow.

Study the many different shapes of trees and familiarise yourself with them. In particular, note how groups of trees appear, and try drawing them within a landscape (page 87).

Observe their effect on each other, and also what they look like when they are creating reflections in water (page 88).

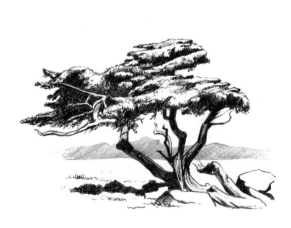

Monterey Cypress

Yew

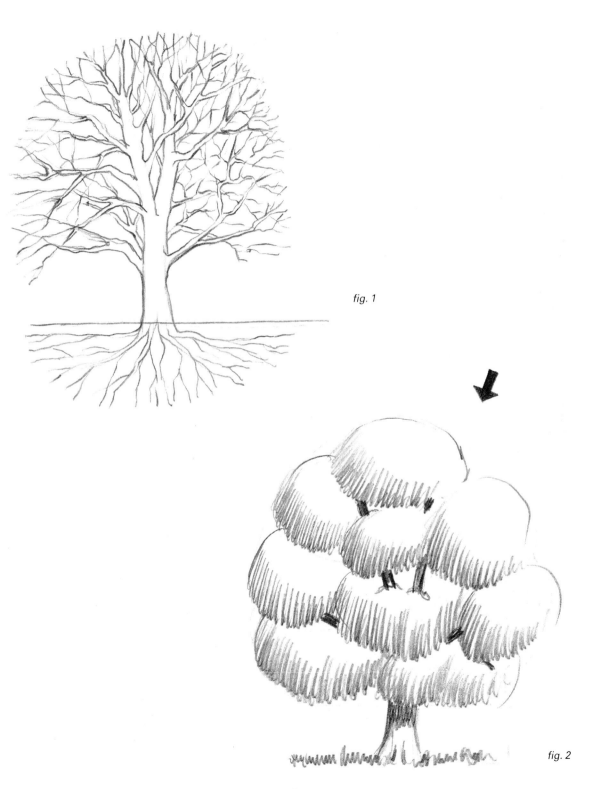

fig. 1

fig. 2

85

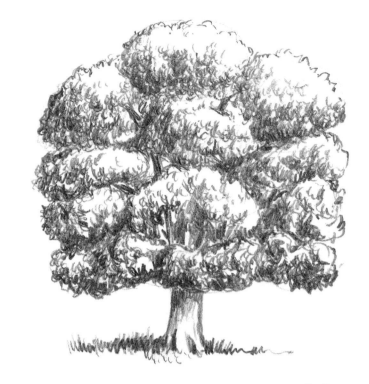

fig. 3

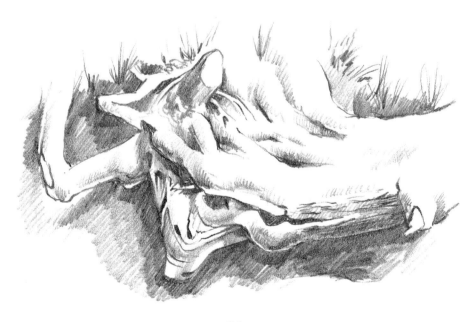

86

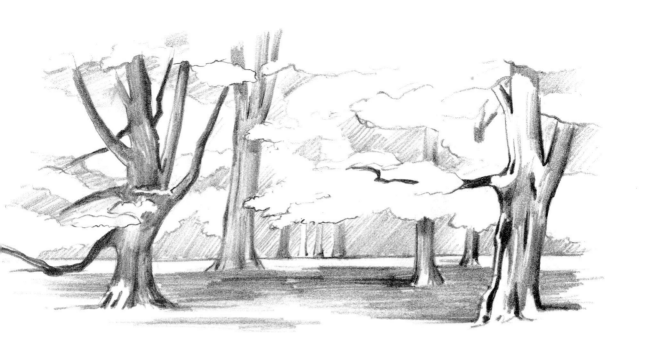

Elm

Norway Spruce

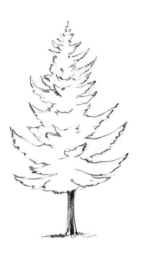

Lombardy Poplar

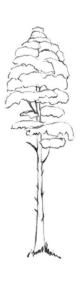

Scott Pines

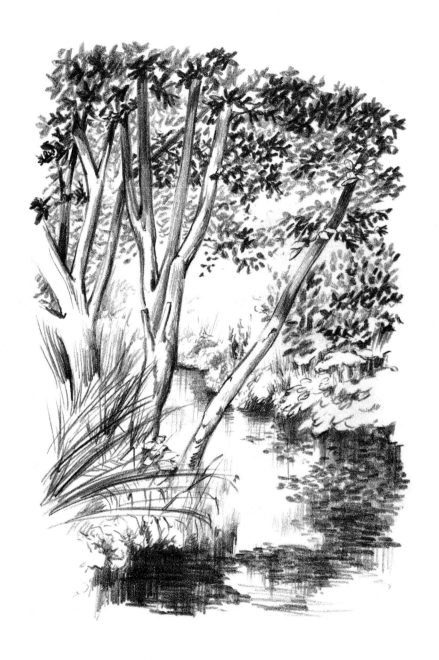

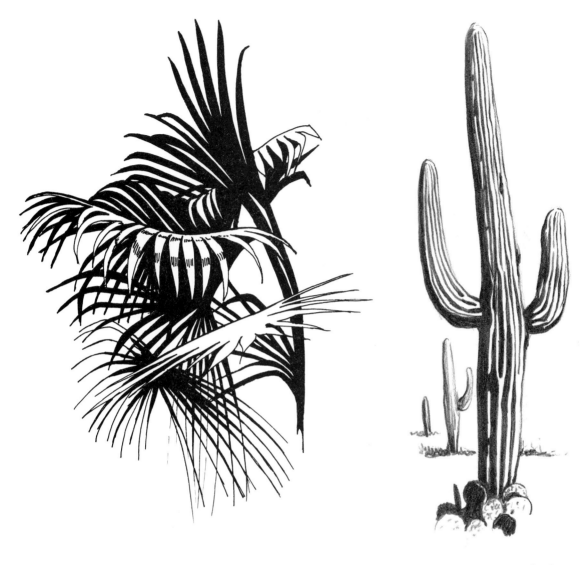

Cacti

The use of different materials and techniques can make a dramatic difference to your drawings. Here are two illustrations of a palm and a giant cactus: one drawn with a pen and Indian ink and made into a pleasing design by using heavy shadows and a few lines, the other (the cactus) using a 4B pencil, again concentrating only on the main lines caused by heavy lighting and shadows.

It will become obvious to the student reading this book that the different techniques suggested cover most subjects; for instance, the method used in these two illustrations is also used in the sections on buildings, cars and trains, boats and water and animals and birds. The same may be observed of other techniques.

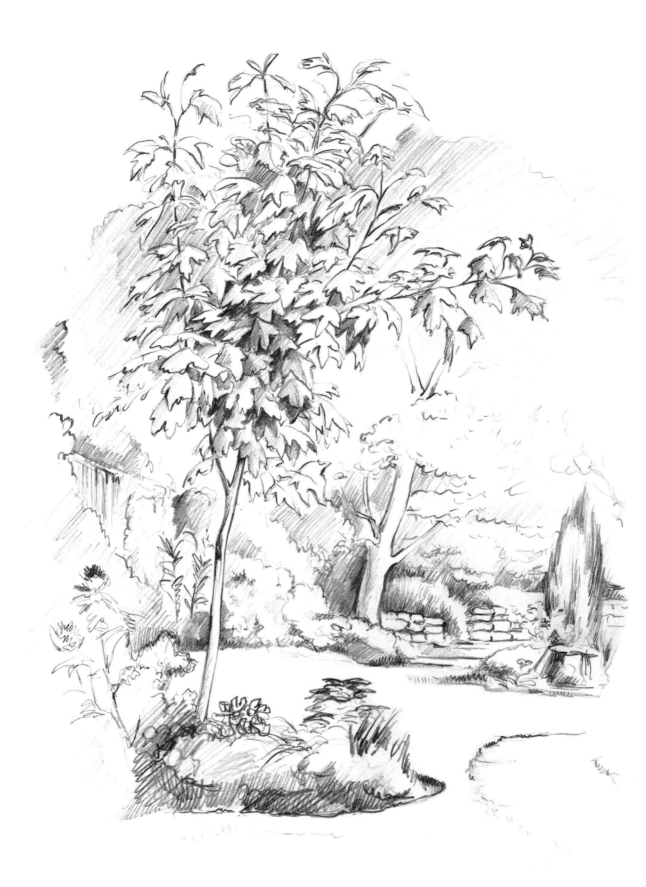

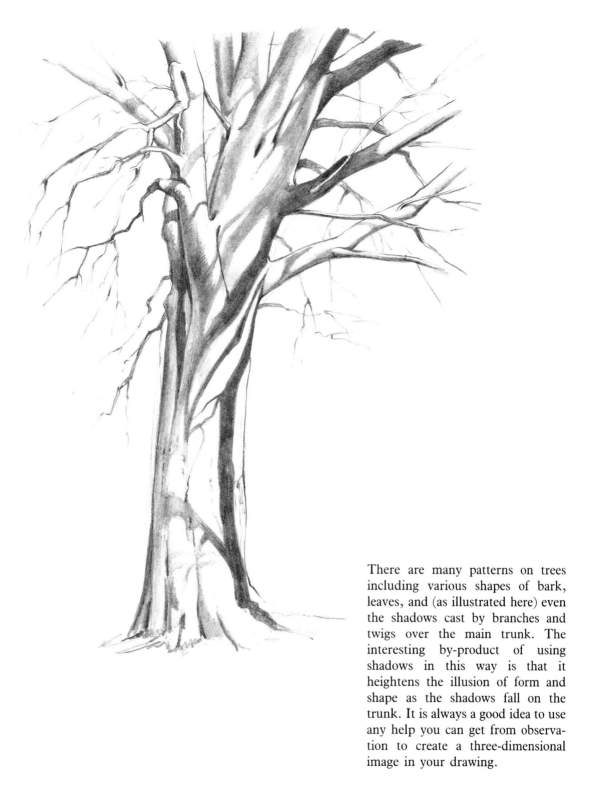

There are many patterns on trees including various shapes of bark, leaves, and (as illustrated here) even the shadows cast by branches and twigs over the main trunk. The interesting by-product of using shadows in this way is that it heightens the illusion of form and shape as the shadows fall on the trunk. It is always a good idea to use any help you can get from observation to create a three-dimensional image in your drawing.

91

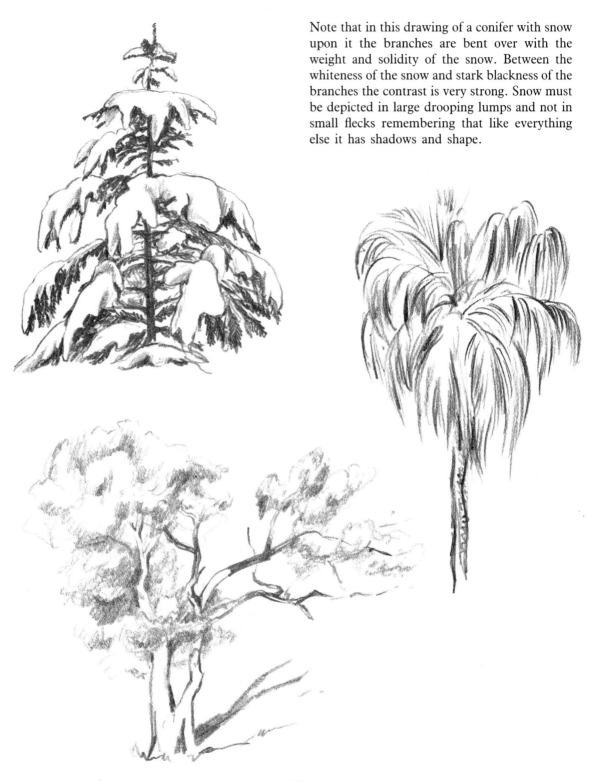

Note that in this drawing of a conifer with snow upon it the branches are bent over with the weight and solidity of the snow. Between the whiteness of the snow and stark blackness of the branches the contrast is very strong. Snow must be depicted in large drooping lumps and not in small flecks remembering that like everything else it has shadows and shape.

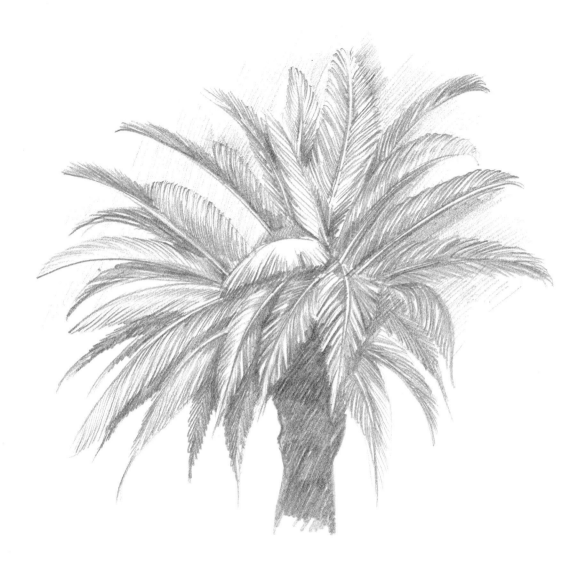

The group of trees and shrubs are drawn here
with subtle but very different techniques.

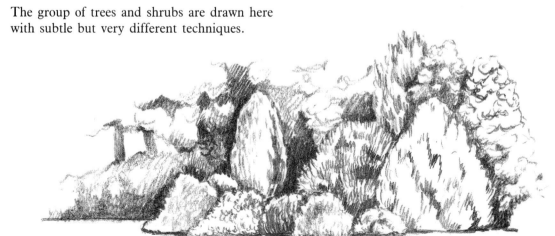

Flowers

Many things that we observe and wish to draw are the cause of panic and bewilderment when we are confronted with what appears at first to be a mass of complicated forms. With flowers, which are usually a confusing welter of petals and leaves, it is particularly important to look for a rational sense of order.

This problem arises frequently in art and a thinking approach must be adopted: that is, concentrate on one small part, analyse its shape, perspective and tone, and draw its basic form. Once this has been done it is easier to move on and add the next form to it. This can be continued until the whole bunch of flowers has been sketched in (see fig. 1).

To get the details correct, again start small, concentrate on one flower–head and draw every petal. Follow this with each flower and left until this stage of the drawing has been completed (see fig. 2).

Now that all the details have been placed in order on the paper it is comparatively simple to put in the light and shade, the texture of the leaves, petals, and all the other components of the bunch of flowers (see fig. 3).

It must be remembered that however complex the subject appears to be, there is always an order and pattern to be found which enables us to analyse it, see it clearly and eventually draw it. Leonardo da Vinci is an excellent exponent of this clear, analytical vision and gives some wonderful examples of drawing a complicated plant (see fig. 4).

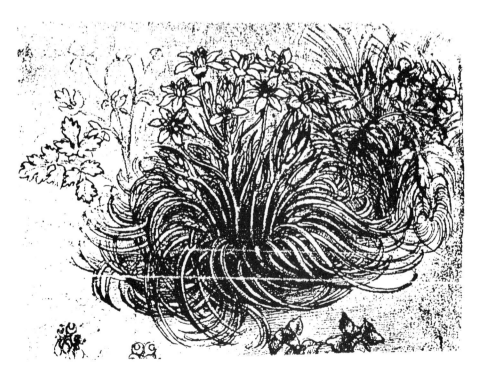

fig. 4

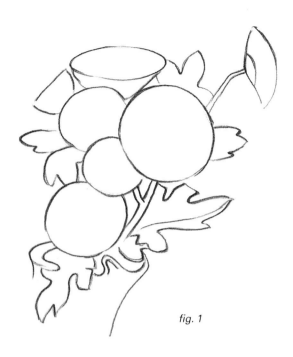

fig. 1

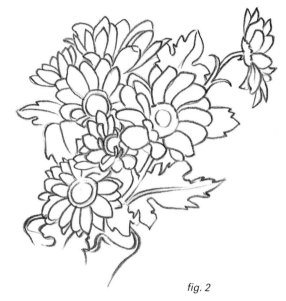

fig. 2

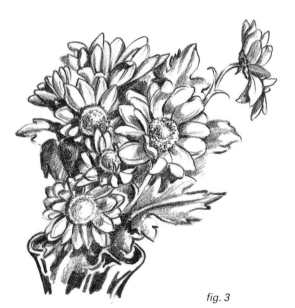

fig. 3

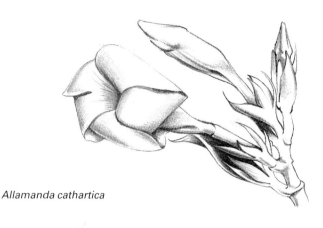

Allamanda cathartica

Illustrated here are various methods of drawing plants. The Acanthus is in pure line whereas the *Cattleya skinneri* is depicted in soft tones and line. The *Allamanda cathartica* above and Clematis are drawn in very definite lines and hard shadows. By contrast, the pot of geraniums and variegated ivy is a composite use of all the techniques plus the use of shadows as a background.

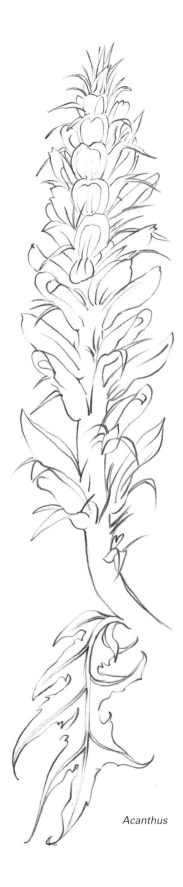

Acanthus

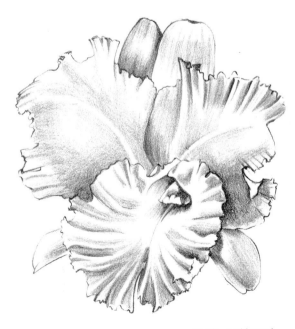

Cattleya skinneri

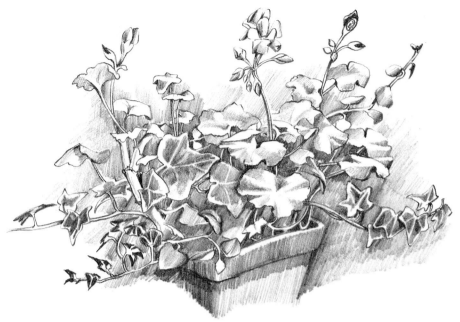

Pot of Geraniums and Varigated Ivy

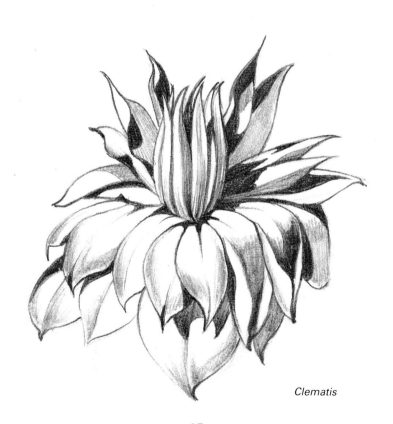

Clematis

97

Primula acaulis

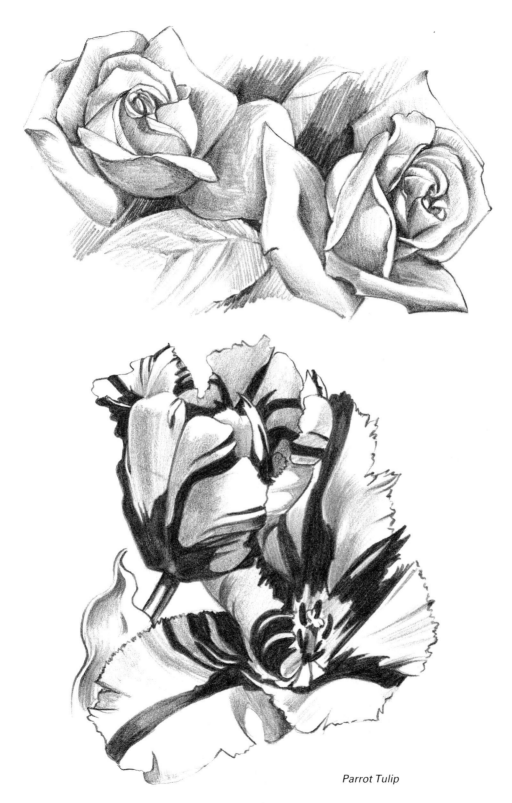

Parrot Tulip

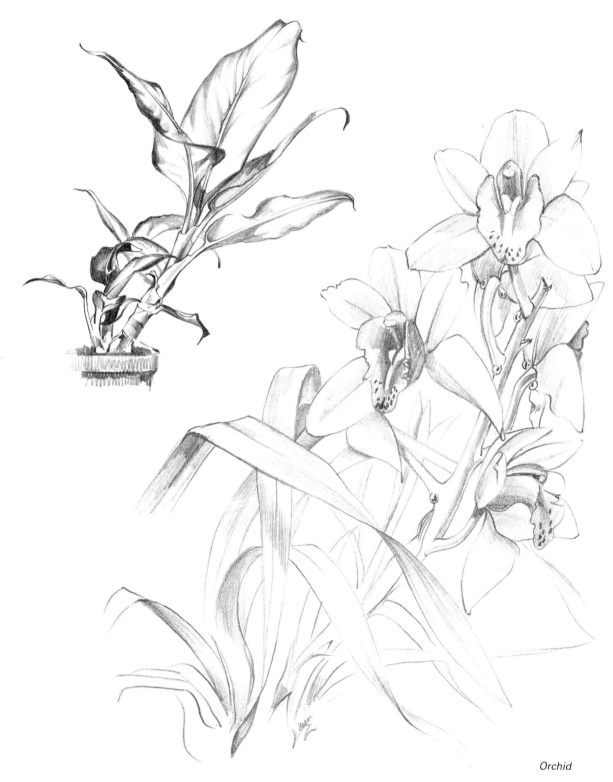

Orchid

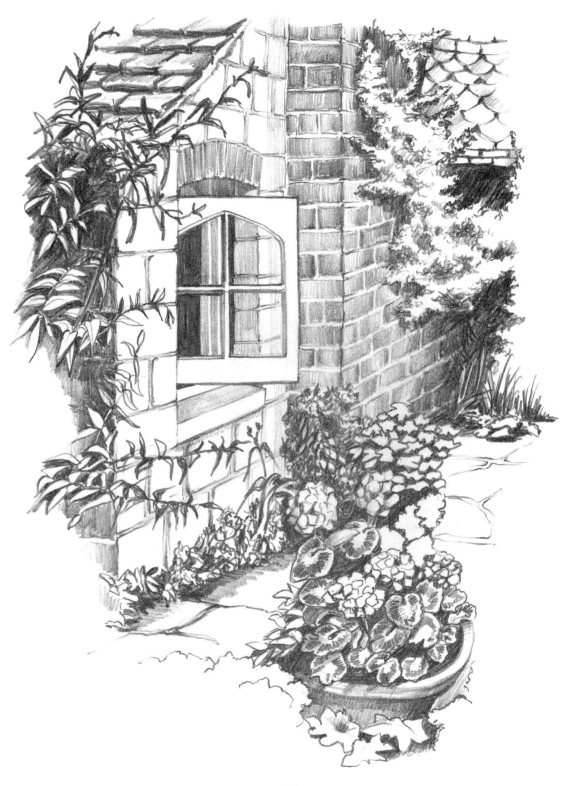

Vine

Chrysanthemum

102

Still Life and Objects

Still life covers the use of any inanimate object, a number of which may be found around the home. They need not necessarily be related and many interesting studies are made by arranging artifacts in a pleasing composition. This exercise is not just drawing objects in a sketch book for use at a later date; it is another form of picture making.

When selecting your subjects it is a good idea to make the central theme something which has caught your eye and which you find exciting – it could be an old lamp or copper kettle – and then to arrange various objects around it in a pleasing composition.

There are various aspects to look for, for example if the main object is metal or glass with a shiny reflective surface it may be a good idea to find another object which has a dull texture as a contrast and which may be reflected into the shiny one. Fruit, vegetables and flowers are very useful in this respect, and so are pieces of drapery which may be arranged so as to tie the whole composition together.

Many examples of still life may be found throughout the history of art and it is interesting to see what other artists have found that has captured their interest and imagination. The usefulness of still life is that, as the term implies, it is not going to go away – you can study it at leisure.

In the artist's armoury should be all sorts of objects which may be used from time to time in still life arrangements. If one is lucky enough to own a studio it should be crammed with wonderful things which are visually stimulating. There should never at any time be a dearth of something to draw.

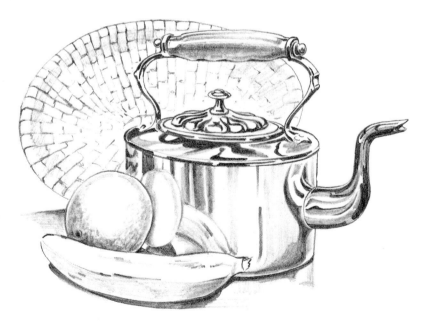

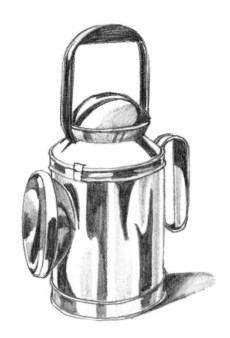

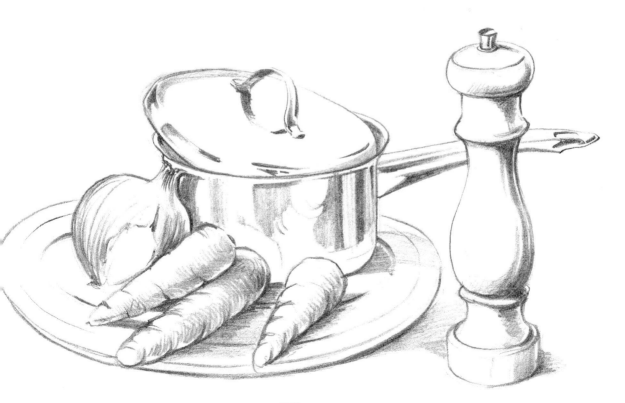

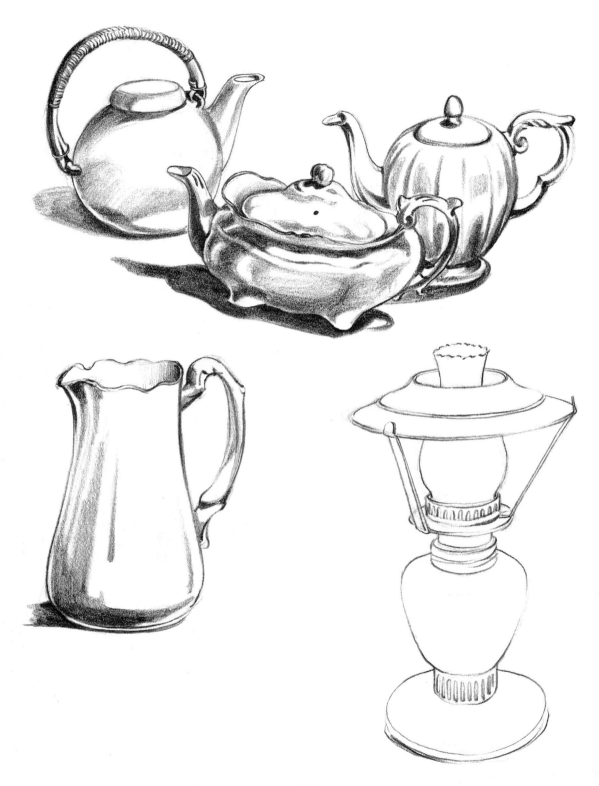

Decoy Duck

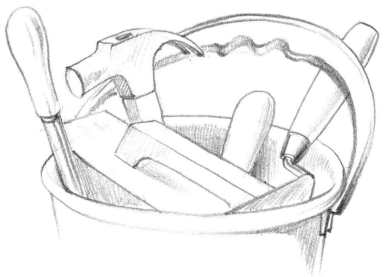

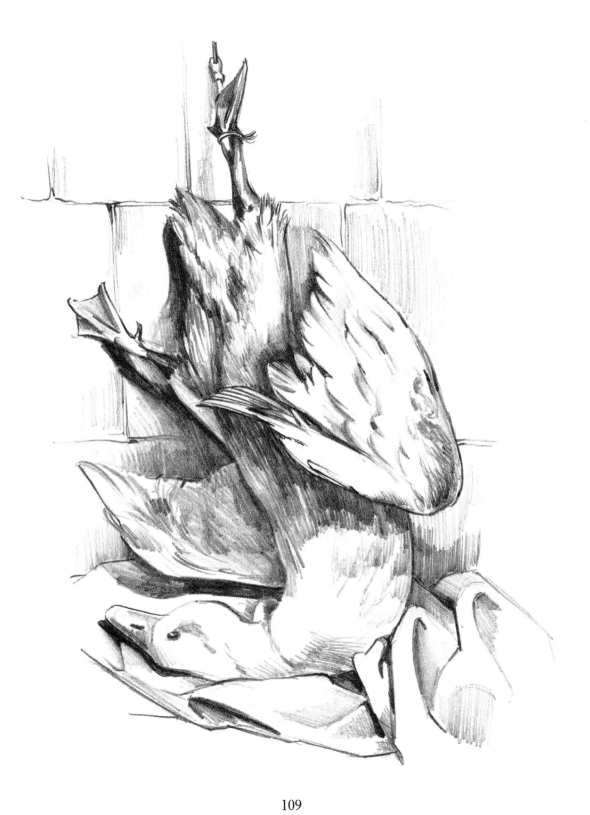

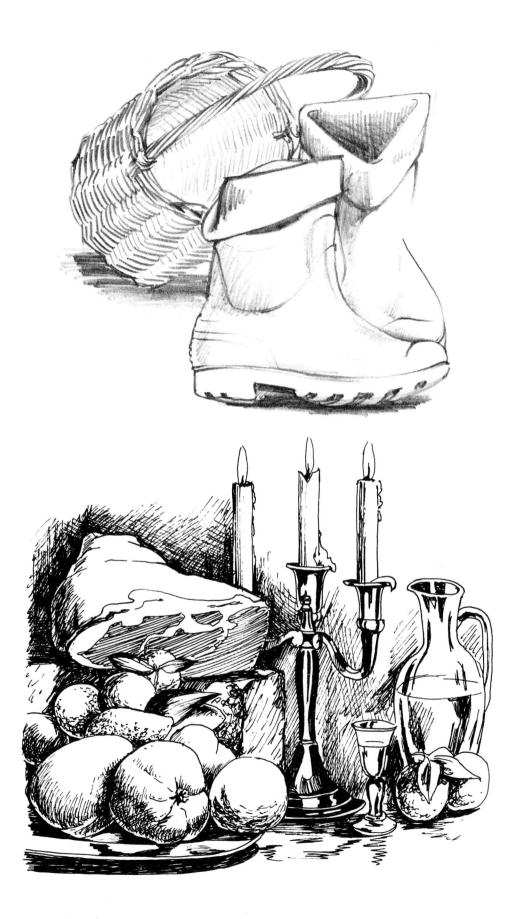

Still life out of doors. There is no need to imagine that still life has to be an arrangement of objects indoors, why not in the open air?

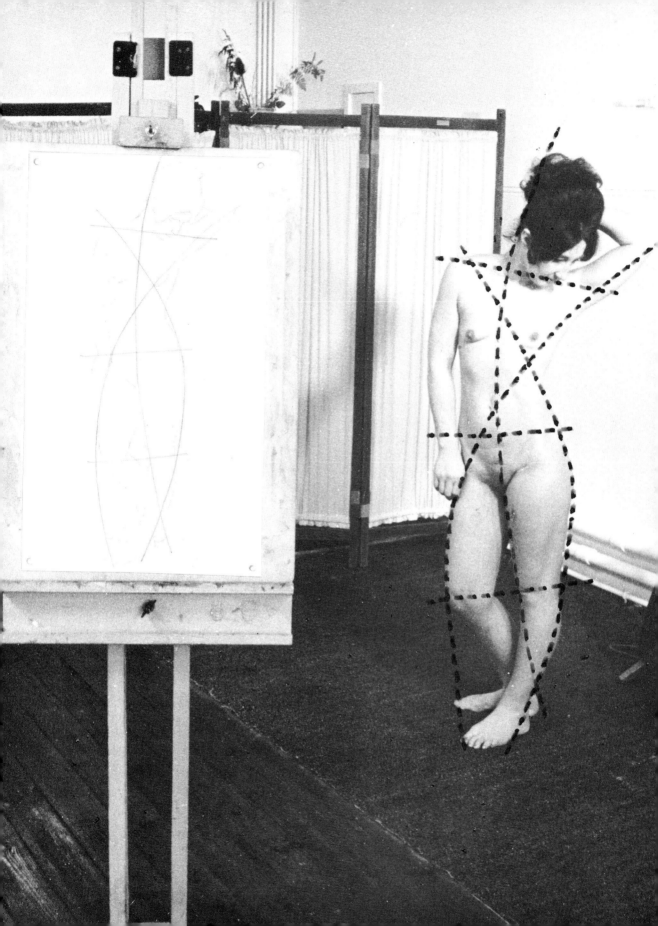

Figure Drawing

Anatomy, what we see and what we use

Following sessions of hard study of anatomy, it is natural to be preoccupied with drawing the intricacies of all we have learned even to the detriment of the life drawing itself. This may sound odd after expounding the necessity of acquiring such knowledge. What I mean is best expressed in the illustrations. Here you will see a drawing which appears as an anatomical diagram thinly covered with skin, rather than a figure which is alive; the knowledge should be in evidence, but more subtly so.

Instead of relying on the only fact we were sure of before, the silhouette, we can now express such details as where the deltoid in the shoulder, for example, folds over and disappears behind the biceps in the upper arm, and how markedly we draw the sartorius sweeping down across the thigh from top to bottom. To draw like this consciously, as an exercise, will certainly help you, but bear in mind that what you have learned is essentially an aid towards your main objective, that of being able to express in visual terms a convincing image on a piece of paper. Anatomy is another tool, just as technique, proportion and perspective are tools.

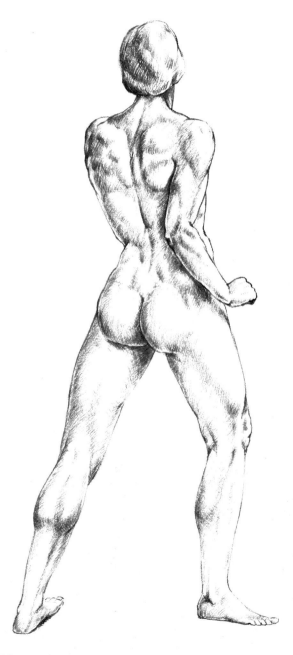

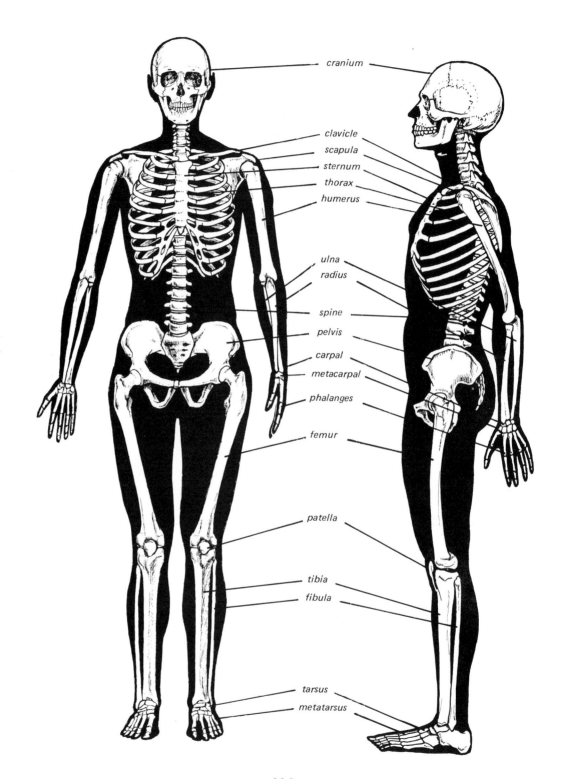

cranium

clavicle
scapula
sternum
thorax
humerus

ulna
radius

spine

pelvis

carpal

metacarpal

phalanges

femur

patella

tibia

fibula

tarsus

metatarsus

116

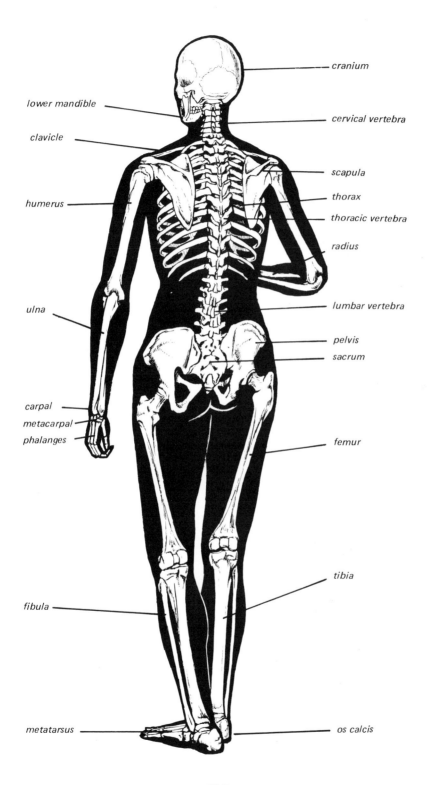

cranium

lower mandible

cervical vertebra

clavicle

scapula

humerus

thorax

thoracic vertebra

radius

ulna

lumbar vertebra

pelvis

sacrum

carpal

metacarpal

phalanges

femur

tibia

fibula

metatarsus

os calcis

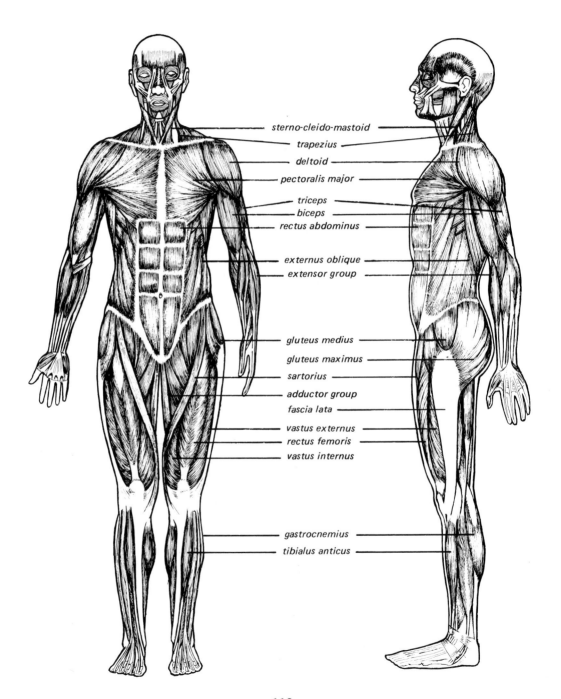

sterno-cleido-mastoid

trapezius

deltoid

pectoralis major

triceps

biceps

rectus abdominus

externus oblique

extensor group

gluteus medius

gluteus maximus

sartorius

adductor group

fascia lata

vastus externus

rectus femoris

vastus internus

gastrocnemius

tibialus anticus

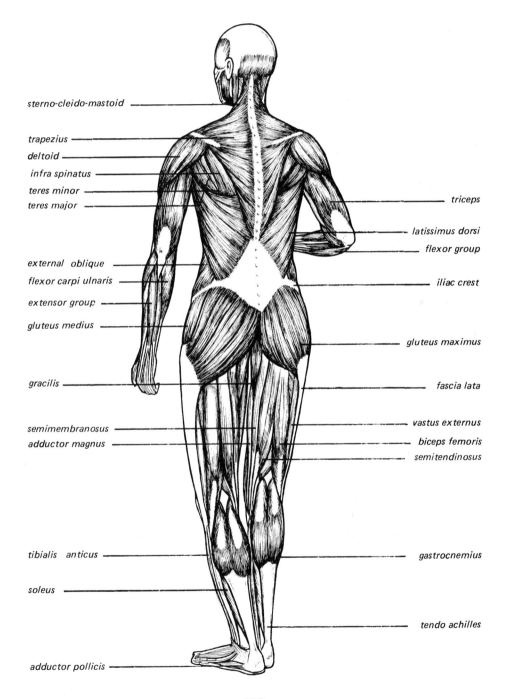

sterno-cleido-mastoid

trapezius

deltoid

infra spinatus

teres minor

teres major

triceps

latissimus dorsi

flexor group

external oblique

flexor carpi ulnaris

iliac crest

extensor group

gluteus medius

gluteus maximus

gracilis

fascia lata

semimembranosus

vastus externus

adductor magnus

biceps femoris

semitendinosus

tibialis anticus

gastrocnemius

soleus

tendo achilles

adductor pollicis

The simple approach

Try to get down onto paper a few of the important design lines of the pose (see illustration) and augment these with some basic construction lines of the body. Within the first few minutes you have settled the size and design of your drawing. At this point your proportion may be checked and if necessary corrected.

There are occasions in drawing from life when we are confronted with a part of the body set at such an angle that it seems impossible to reproduce the image onto a piece of paper.

We are dealing here with an element known as perspective and it is by the simple rules of perspective that we can overcome our difficulties and represent faithfully on paper the image in front of us.

We will be using such terms as horizon or eye lines, vanishing points, ellipses, etc., and we will be reducing the various parts of the body into simple cubes, tubes and spheres. With practice all this will become second nature.

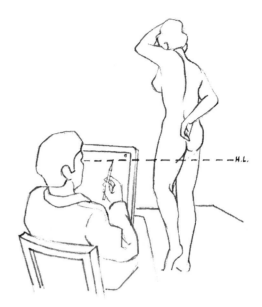

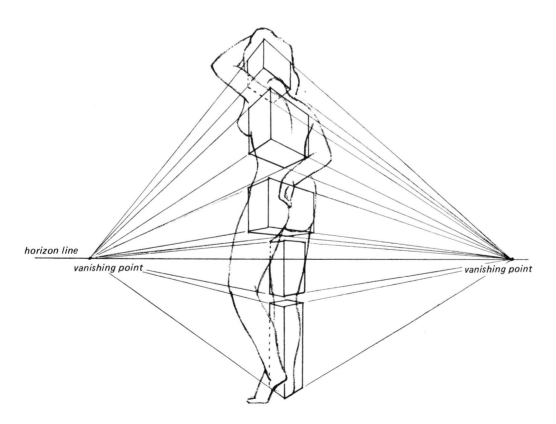

horizon line

vanishing point vanishing point

121

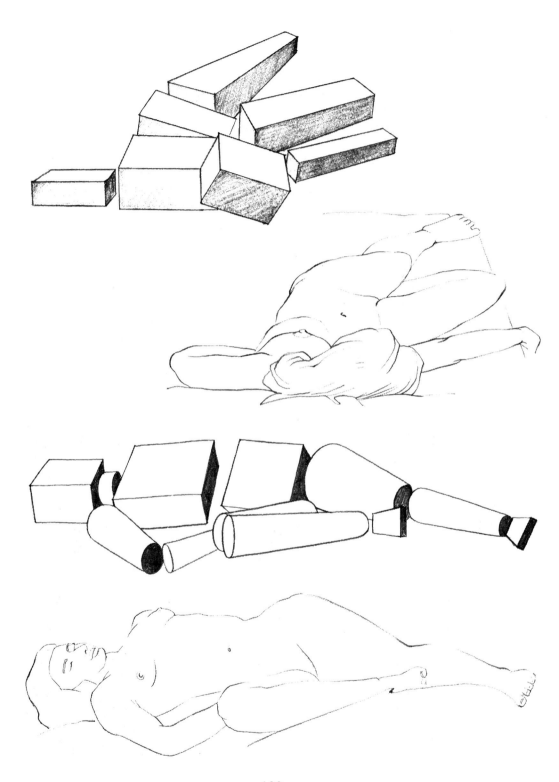

Negative spaces

One very successful aid in drawing is to visualise negative spaces. You will find that it acts as a check in ascertaining whether or not the proportions are correct, and also helps in seeing the figures as a design. The simplest way to understand this method is to study the illustrations.

In some of the drawings the spaces left around the model have been outlined and in others they have been shaded leaving the model in blank white silhouette. Both these methods should be practised as they prove useful exercises in training the vision as well as one's skill with the pencil.

There are times when you will wish to incorporate this method with line and various techniques described in a later section.

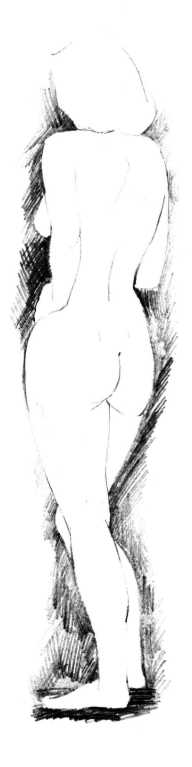

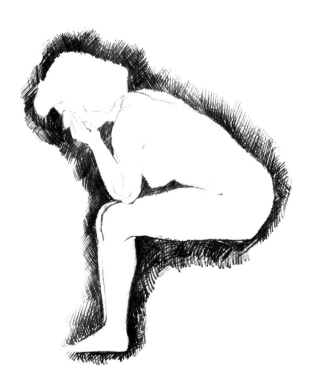

123

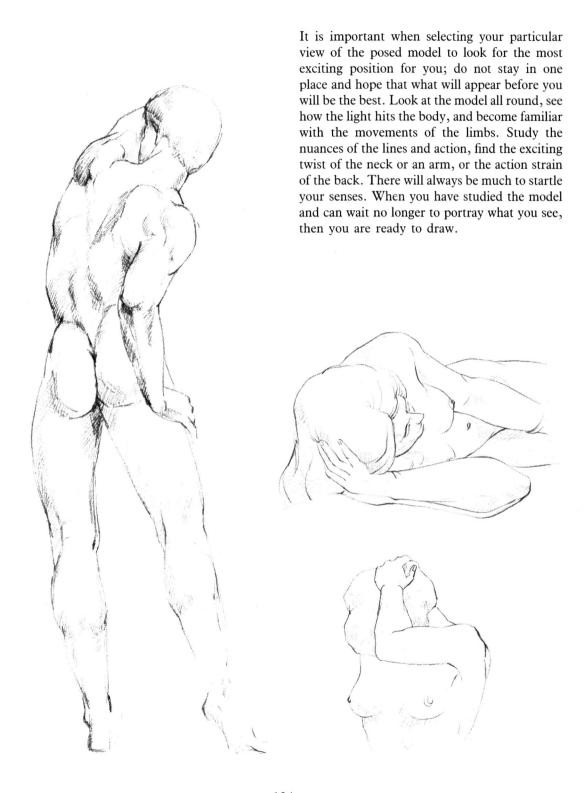

It is important when selecting your particular view of the posed model to look for the most exciting position for you; do not stay in one place and hope that what will appear before you will be the best. Look at the model all round, see how the light hits the body, and become familiar with the movements of the limbs. Study the nuances of the lines and action, find the exciting twist of the neck or an arm, or the action strain of the back. There will always be much to startle your senses. When you have studied the model and can wait no longer to portray what you see, then you are ready to draw.

124

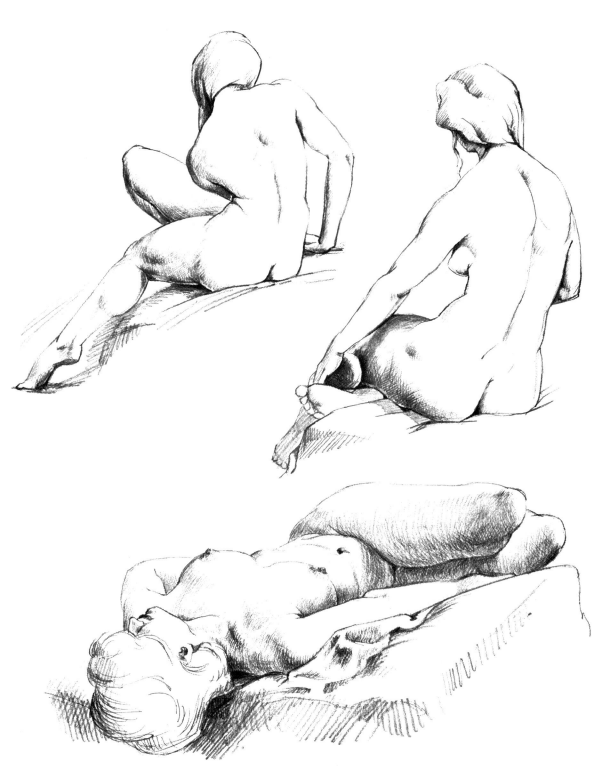

Hands and feet

One of the most neglected areas of life drawing are the hands and feet. For some strange reason many people seem to think that all that matters is the torso and perhaps the head. It is possible that they feel that hands and feet are difficult, complicated and even at times ugly, and therefore shy away from attempting them in their drawing.

Hands and feet are no more or no less difficult to draw than any other part of the body, and as they are so expressive and vital to our every motion they should not be treated as mere appendages.

One has only to take a ballet dancer to see a supreme example of beauty and expressiveness. It would be inconceivable that a drawing of a ballet dancer should be minus hands and feet, similarly we all in our ordinary daily lives express much of ourselves by gesticulations with our hands and our stance with our feet.

Let us examine the construction of these sections of the body and see what is involved.

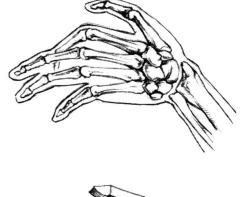

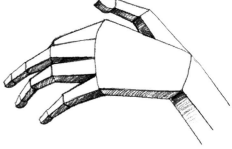

Hands

The hands follow the form of the bone structure very closely with only a few muscles to alter the image. The illustrations will explain what I mean.

Once you have understood and assimilated these points, hands should no longer present such a problem for you. They are not such complicated structures. It should be mentioned here not to focus too much on details such as the skin creases or the finger nails. It is only necessary to indicate these and to show where direction changes or overlapping occurs so as to define clearly what the hand is doing.

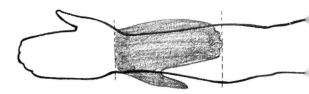

126

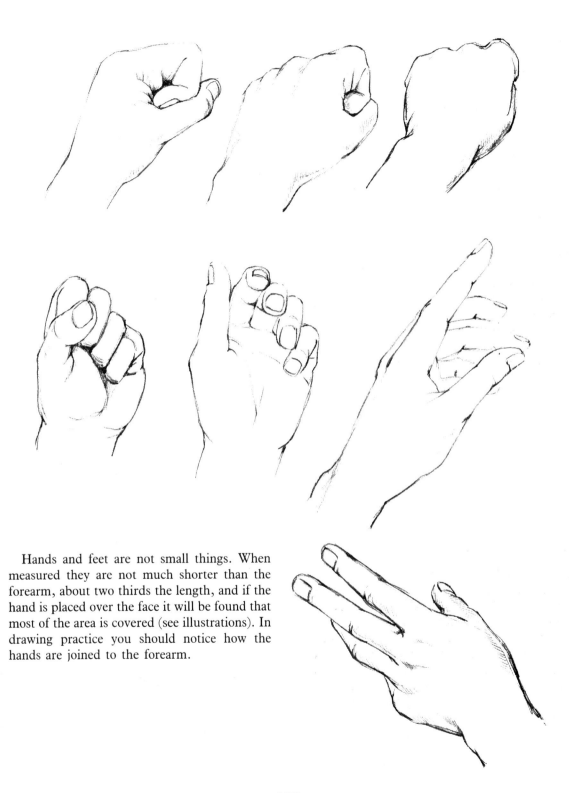

Hands and feet are not small things. When measured they are not much shorter than the forearm, about two thirds the length, and if the hand is placed over the face it will be found that most of the area is covered (see illustrations). In drawing practice you should notice how the hands are joined to the forearm.

Feet

Feet are very similar to hands in terms of bone construction, but unlike hands, they are mostly hidden by overlying skin. Only where the toes appear is there a hint of any similarity. In drawing, it must be remembered that toes are quite active and that they help with the balance of the body.

In size the feet are large parts of the body. The foot is as large as the distance from the heel to half way up the lower leg and the toes would touch the swelling of the gastrocnemius.

One of the beauties of the pointed foot is that it gives a long sweep from the knee down to the big toe. Much of the grace and spirit of movement will be lost if you ignore these members as they are essential to the rhythm and fluidity of the whole.

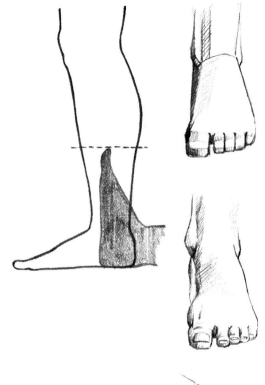

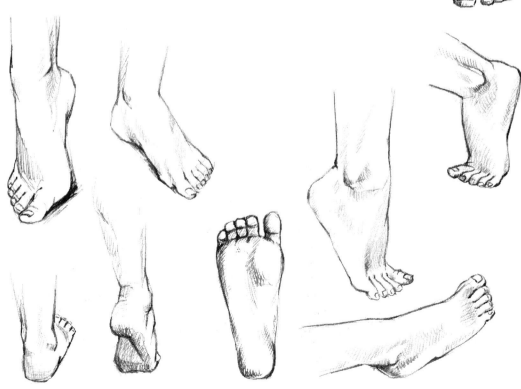

128

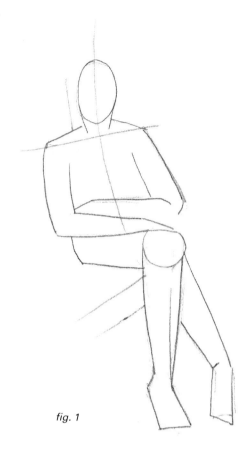

fig. 1

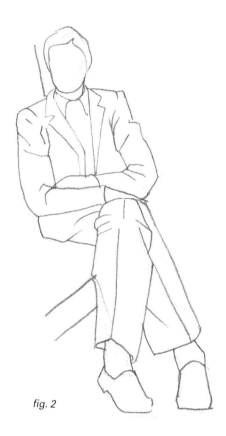

fig. 2

When drawing a figure with clothes on it is important to sketch in the basic human form first, giving yourself directions and angles to guide you. It will help also to establish the stress points which affect the clothes. Fig. 1 shows the rough of the body with its directions and fig. 2 sketches in the main lines of the clothes. From this beginning one can carry on to put in all the details of the clothing plus the light and shade.

It is necessary to get someone to act as a model for you. This can often be done in the comfort of your own home with a friend or member of your family posing. Page 130 illustrates a sketch of my wife doing some needlework, almost unaware that I was drawing her. Look for the main stress points, where clothes fall from shoulders, and where the cloth is folded at the elbows, knees and hips. In active work or play the position of the clothes on the body in action is very important.

Practise drawing clothes and drapery; hang pieces on the back of a chair and observe how they hang. Another method of studying drapery is to simply drop a piece of material on the floor and draw what you see (page 131).

Page 130 shows some stick figures which I find useful when working out the poses I want to establish. It is also useful for practising hanging clothes on.

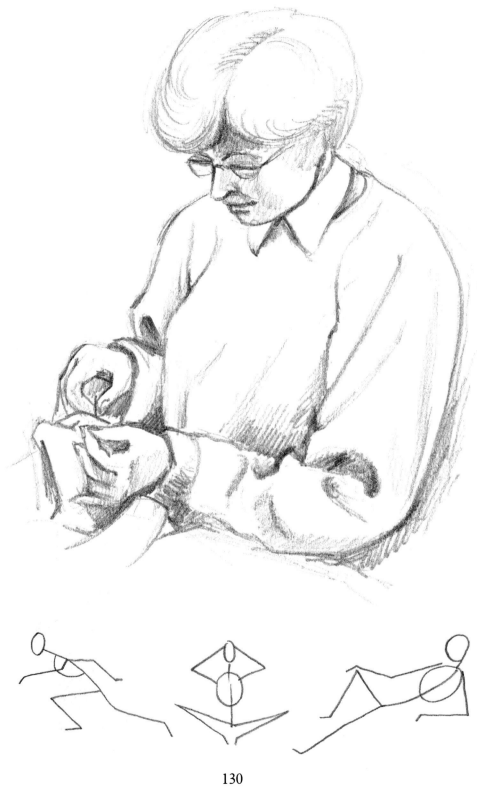

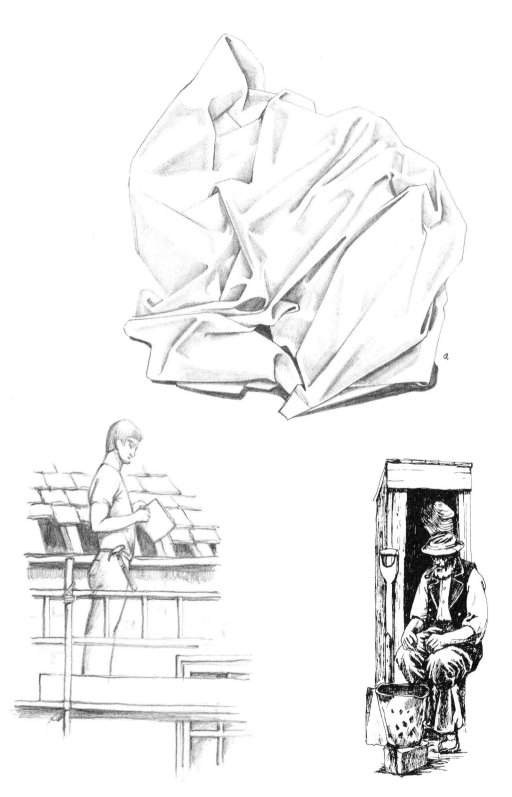

131

Portraiture

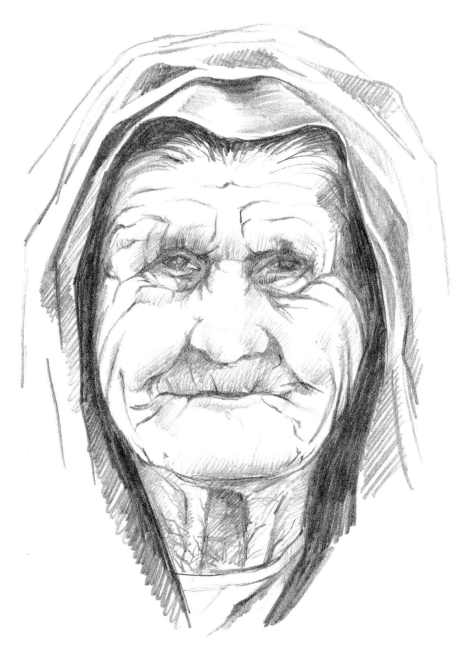

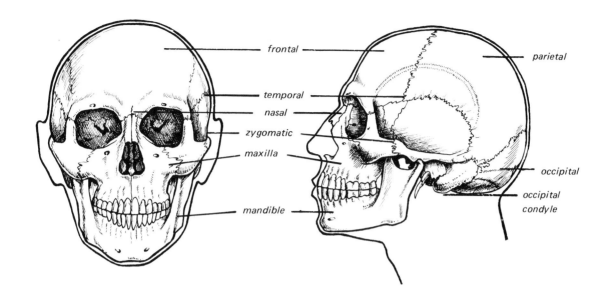

The skull

For our purposes we can look at the skull as a whole, consisting of a series of bones fused together with one movable part, the jaw bones. If we study the illustrations we can see that the *cranium* is made up of the *frontal*, *parietal*, *temporal* and *occipital* bones; the peculiar joining lines are known as *sutures*. From the front aspect will be seen two large holes which house the eyes, the *occipital orbit*; also a pear shaped hole bridged by the *nasal* bones which is the framework for the nose. A large proportion of the nose is made of soft occipital orbit begins the cheek bone or *zygomatic* (malar) and this runs along the side of the head getting narrower and forming an arch until it rejoins the skull at the ear. The final static bone is the *maxilla* or upper jawbone which holds all the upper teeth. The movable part of the skull is the lower jawbone or *mandible* and this easily recognised shape houses the lower teeth in the front and sides and ends in two upward sweeps which lock into the skull in a hinge joint underneath the cheek bone.

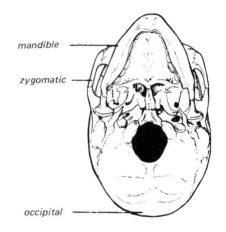

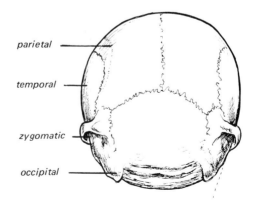

133

The head and neck

The two pronounced muscles which appear diagonally from behind the ear to the head of the sternum are the *sterno-cleido-mastoids*. They also have another small part which comes from behind and is attached to the top edge of the clavicle. There are various muscles in the throat but what concerns us is the *pomum adami*, adam's apple. This is more obvious in males than females. It is well to note its location from the illustration.

The head and facial muscles can be best assimilated by studying the illustrations as the facial muscles are so numerous and our pre-occupation should be with those which operate facial expression.

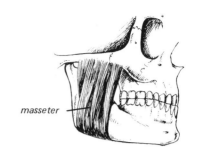

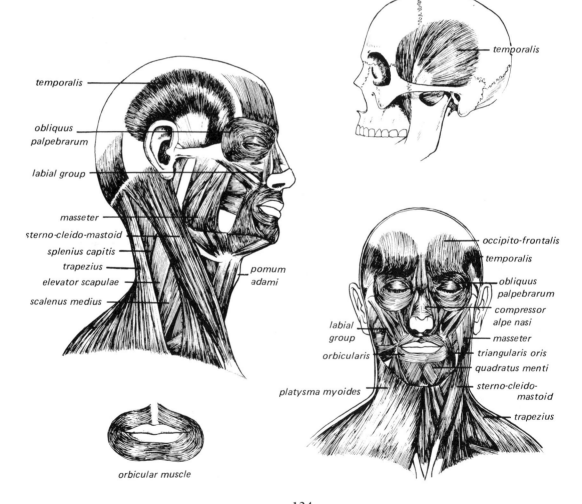

orbicular muscle

134

It is very easy to become bogged down with small detail and lose the large overall concept. To overcome this it is advisable to consider the broad aspects of the model and reduce them to a series of blocks and planes. A knowledge of perspective and the use of light and shade will help you with this.

From the illustrations you will see how to break the figure down, firstly into large areas and then into smaller ones. This then becomes a firm basis on which to work. To start with it will help to practise this approach quite deliberately but in time you will see what is necessary in the mind's eye and will then only have to indicate general points on the paper. Eventually you will be able to visualise the drawing before you start.

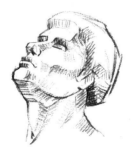 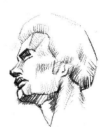

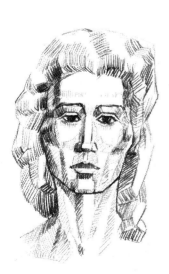

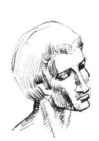

135

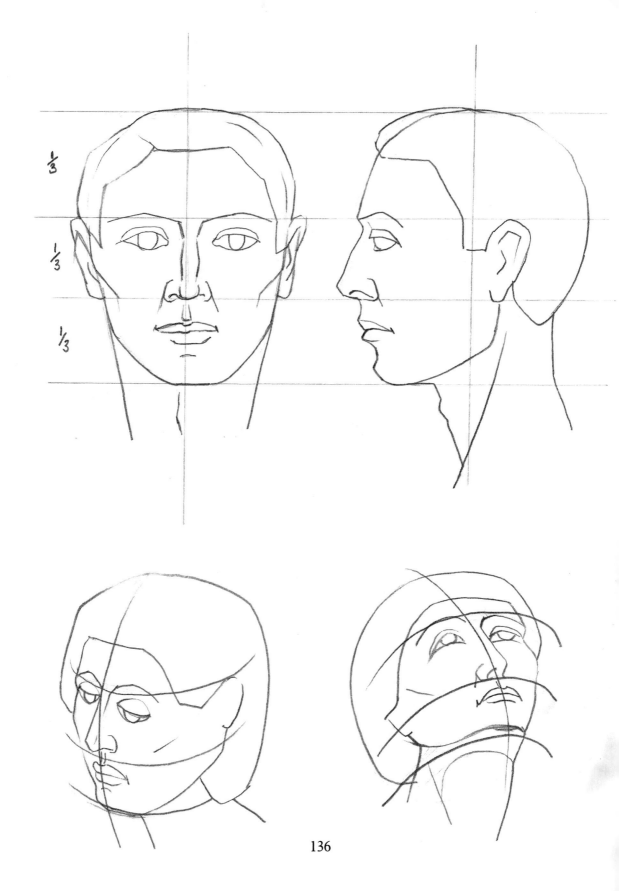

$\frac{1}{3}$

$\frac{1}{3}$

$\frac{1}{3}$

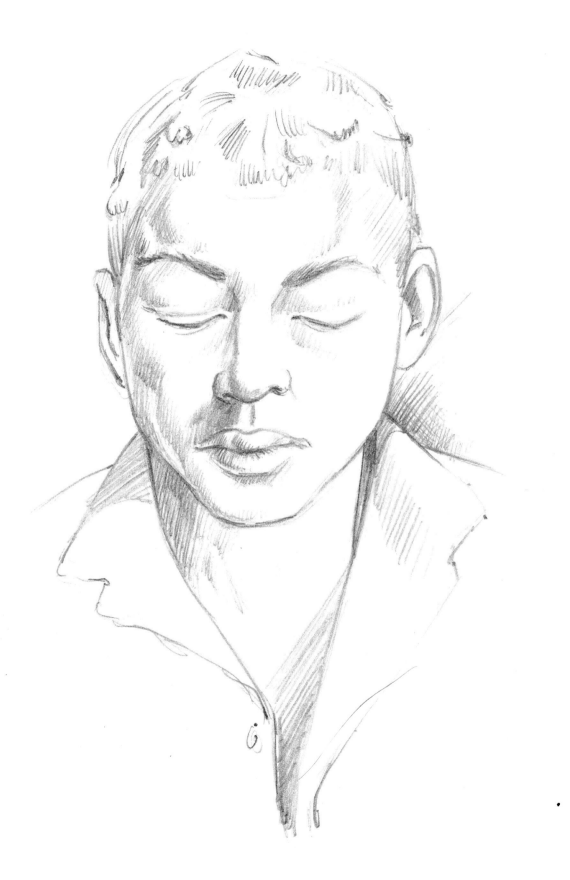

Constructing pictures

Composition generally has a few basically acceptable rules which are as well to know as this knowledge can make or mar a picture. Too often one can see beautifully drawn or painted details but the whole concept is spoilt by bad composition.

The page of diagrams overleaf show simple rules to study, remembering always that rules can be broken; but when you wish to break a rule it is advisable to do this with understanding to a specific end rather than from ignorance.

Series A starts with a bad figure (1) which is divided in half. This picture would be boring; it is better to follow 2 or 3, which divide the picture into one third and two thirds and this immediately gives a start of interest with two different shapes.

Series B is similar but using diagonal lines instead of vertical. Diagram 1 is boring, but 2 or 3 are more interesting.

Series C follow the same pattern as A and B.

Series D is an extension of series C. The additional lines indicate extra details or movements which always turn back into the picture, returning the eye to the main subject matter and do not allow the eye to wander out of the picture frame. Diagram 2 in this series is a classic design based on the triangle.

The application of these simple rules starts when you have decided on your subject and assembled all your notes and sketches. If, for instance, you have decided to draw a bird on a tree branch, establish where in the picture you wish the bird to be then by altering the angles of the branches you can keep the eye into the picture. Look at series E and note how the rules already described have been used:

1 The basic picture;
2 The bird placed on the $\frac{1}{3}-\frac{2}{3}$ vertical line;
3 The branch placed on the $\frac{1}{3}-\frac{2}{3}$ diagonal line;
4 The extra branches leading the eye back into the picture.

The examples of pictures show variations on these themes and can be used as guides for your own picture making.

golden eagle

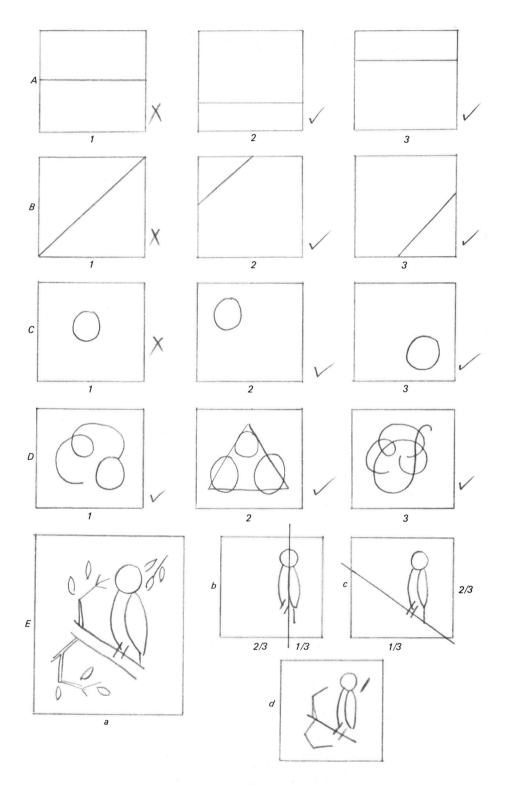

139

Note how in diagram A the boat seems to be falling out of the picture. Diagram B allows a comfortable space as the prow of the boat has a long way to travel before hitting the picture frame.

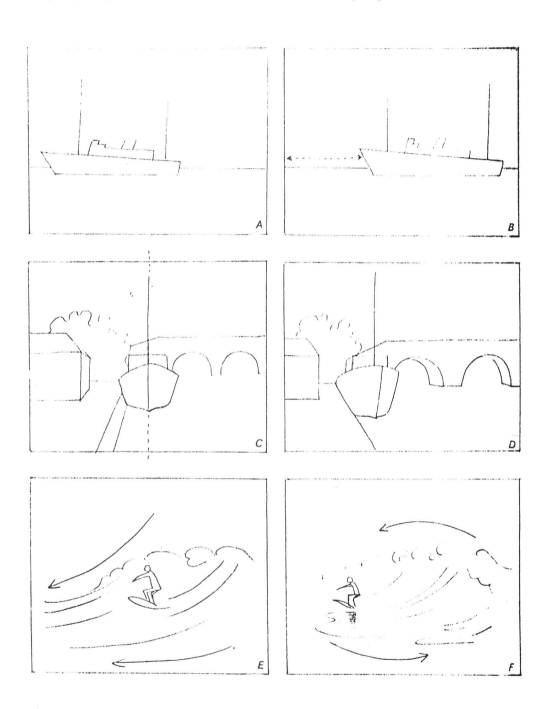

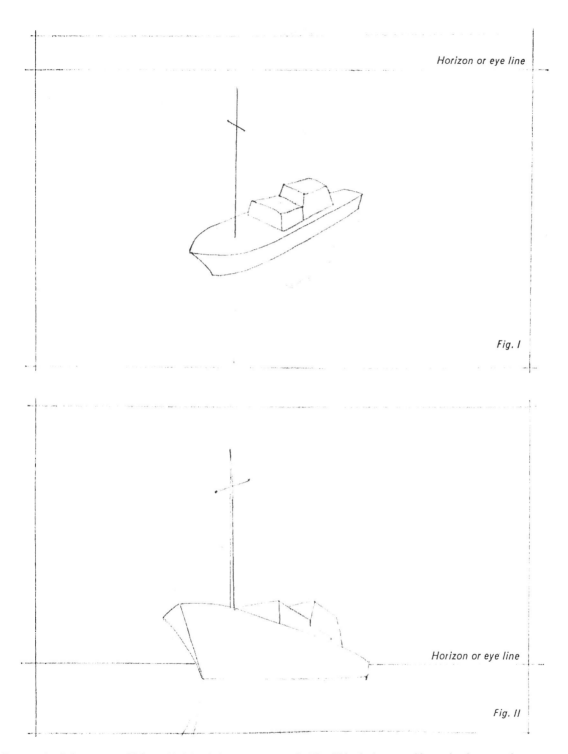

Horizon or eye line

Fig. I

Horizon or eye line

Fig. II

Perspective is important. Using a high horizon makes the boat look like a toy as in Fig. I, whereas the boat in Fig. II looks large and imposing because the horizon has been placed low in the picture.

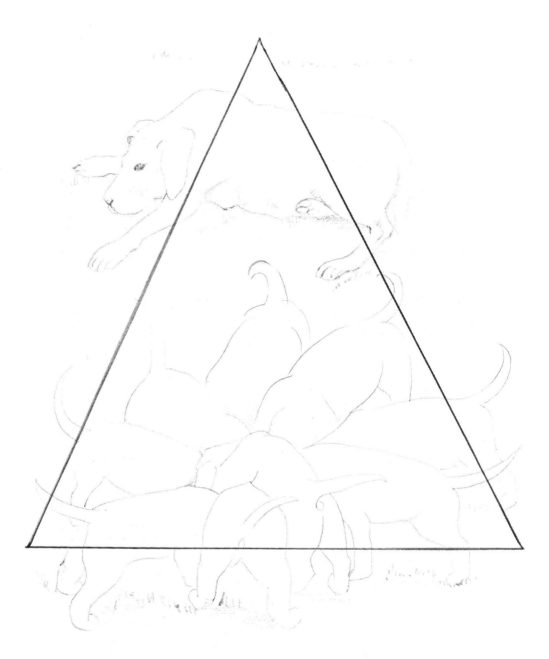

This is a classic triangular composition, note the
diagram D.2. on page 139.

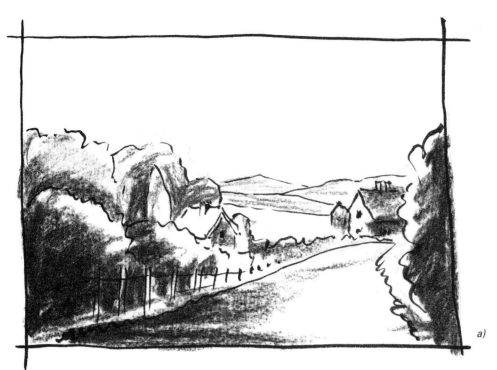

a)

Diagram a) shows the use of perspective in composition. The road and fence leads the eye to the focal point of the cottage at the end of the road. It also uses tonal perspective where the trees in the foreground are darker than the hills in the far distance creating the illusion of depth.

Diagram b) uses the lane and the clouds to bring the eye back into the picture and focuses on the windmill in the middle distance.

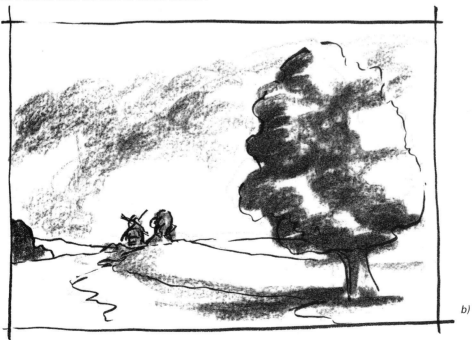

b)

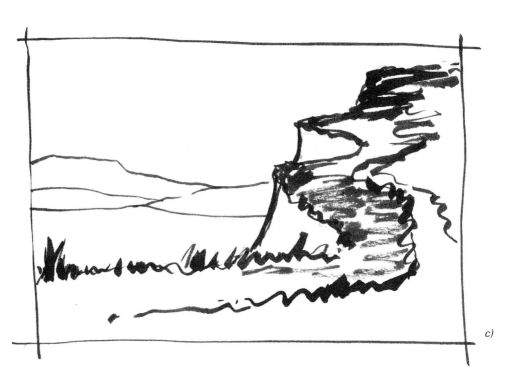

c)

Diagram c) and d) increase the effect of distance by using the cliffs and tree very prominently in the foreground.

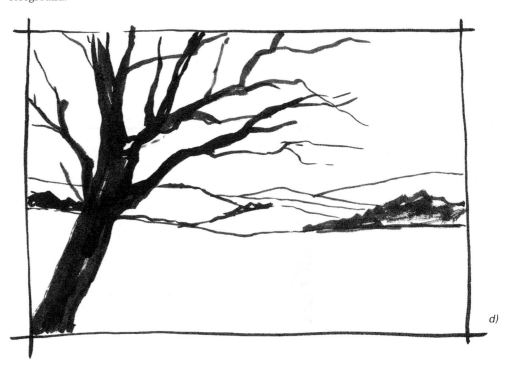

d)

Decoration

One of the things we tend to miss when we are busy drawing all the aspects already covered in this book is the glorious richness of decoration which is all around us.

The most obvious feature which comes to mind is architectural ornament. There is much to catch the eye on old buildings, in the way of sculptured stone decoration, ornamentation around doors and windows, and ancillary items such as lighting fittings and gable ends.

Other avenues offer a bountiful supply of lovely things to draw: see, for example, the page on figure heads of old ships. Costume is another source, in fact almost everywhere you look there is something of interest to catch your eye.

There are times when some such ornament added to your drawing achieves an authenticity of observation which makes your drawing unique. Then there is the aspect of drawing pieces of decoration merely for the joy of drawing lovely shapes and playing with light and shade and various techniques. The main thing is to keep looking and keep on drawing.

Fanlight

'Old Turk'

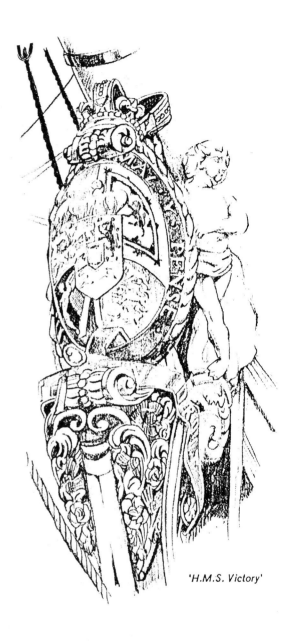

'H.M.S. Victory'

'Volunteer'

Figure-heads

Some of the most fascinating things to draw on old ships are the figure-heads. They are so beautifully carved and add so much romance to the sea and ships that it is a pure joy to draw them for their own sake if nothing else.

146

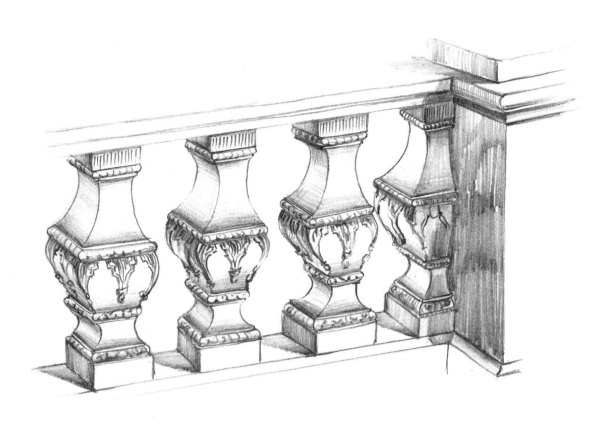

A decorative French balustrade and an Indian parapet.

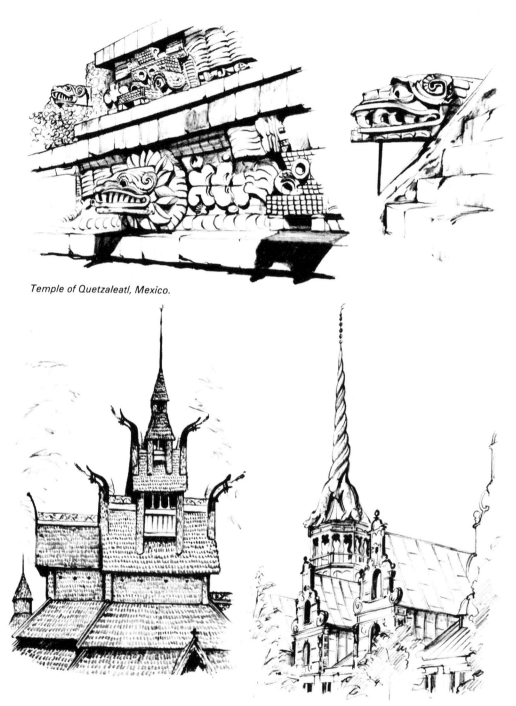

Temple of Quetzaleatl, Mexico.

Fantoft Stave Church, near Bergen, Norway.

Copenhagen Stock Exchange, Denmark.

a)

b)

c)

d)

a) 18th century Handle
b) 17th century Wrought iron 'cocks-head' hinge
c) 18th century Wooden carved bracket
d) Mosque decoration, Bengal

Pen, Brush and Charcoal

Drawing with a brush and ink, or charcoal, has a liberating feeling. With the best will in the world there are times when a pencil can be a little restrictive and analytical. All you need is a number 1 or 2 watercolour brush and a pot of Indian ink and then to draw freely from your subject. Don't worry about mistakes. If you are not happy with your first effort, throw it away and start again. Be prepared to do many drawings.

The illustration of the bridge on this page depicts the use of brush but also pen. Sometimes the contrast of sweeping brush strokes and tight pen lines helps to add interest to your drawing. Further on in this section there are charcoal drawings, also mixing techniques and media.

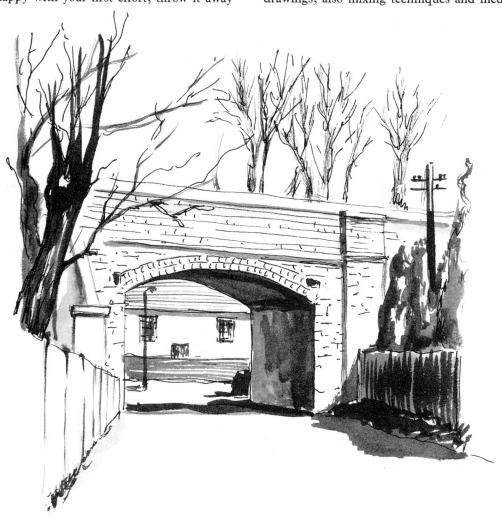

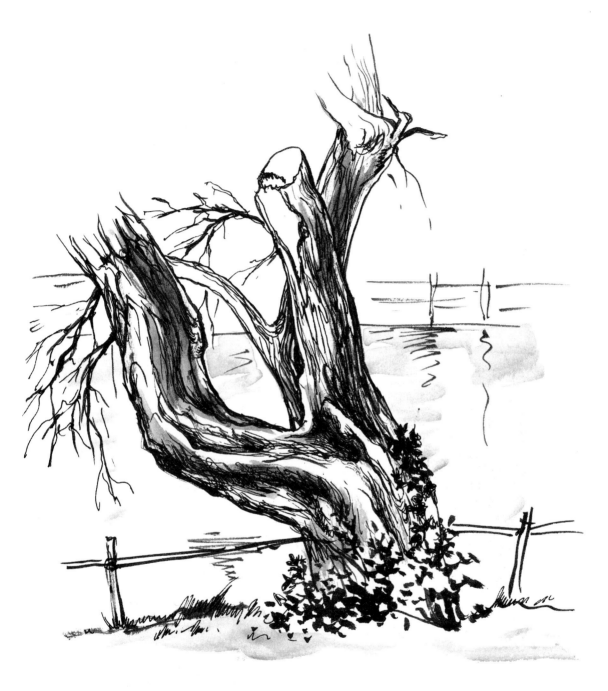

This tree by the river is another example of brush and pen work but with a little difference this time, obtained by wiping most of the ink off the brush before application. This is called 'dry brushing'.

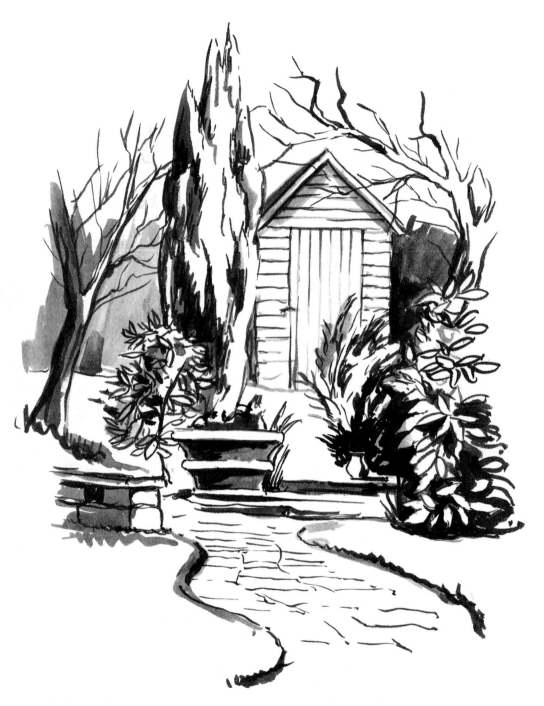

This drawing of part of the author's garden is pure brushwork. Even though some fine lines are included with a number 1 brush, they have a softer feel than a pen line.

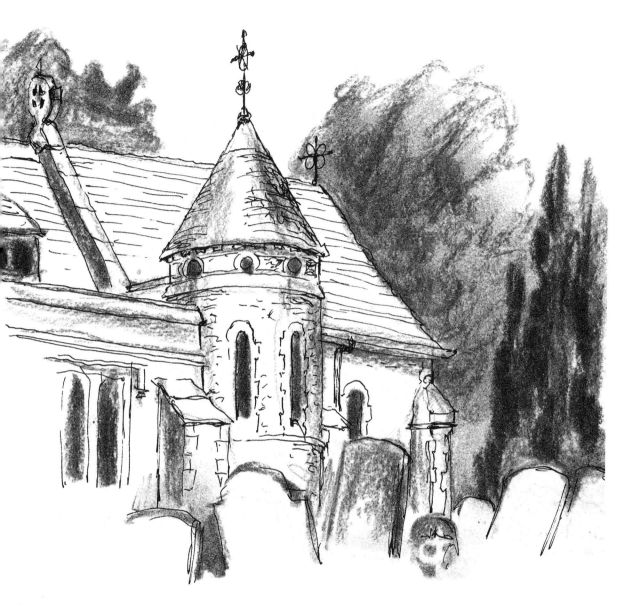

Always use a good quality charcoal, you will find that you can achieve as much softness or hard density by contrast as you wish. The drawing of part of a church is charcoal and pen and ink. There are many combinations of media and it is fun for you to experiment and find your own favourite method. The illustration on page 154 is pure charcoal. The sky shows the effect of rubbing the charcoal with the finger and also the effect of wiping out some of the background charcoal using a putty rubber. You will find that there are a lot of techniques, 'drawing' with a putty rubber in the negative is one of them. Some people call this technique charcoal painting.

It must be remembered that a fixative spray, usually from an aerosol can, should be used as soon as possible after finishing a charcoal drawing to avoid damage by smudging.

This drawing is using charcoal in its purest, simplest form.

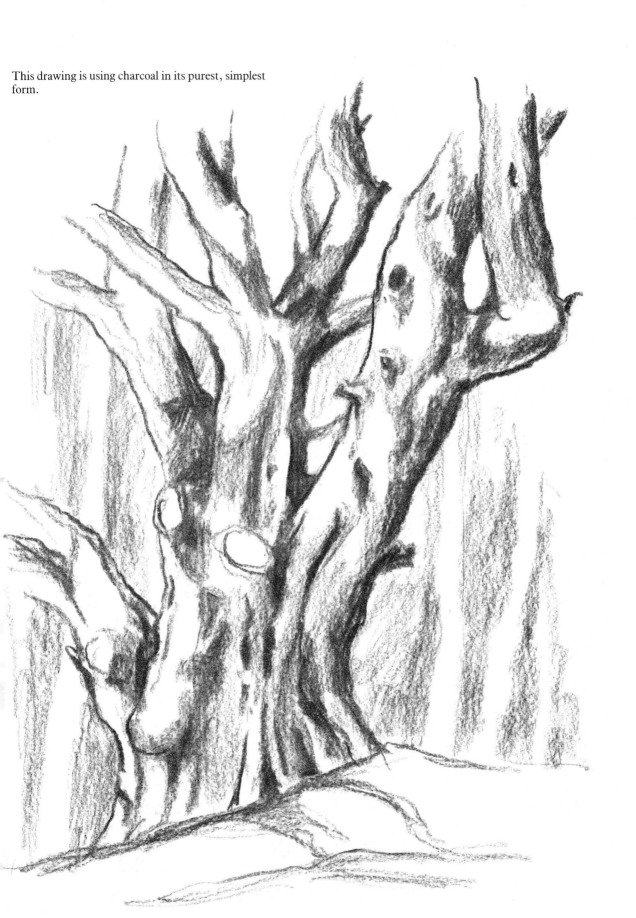

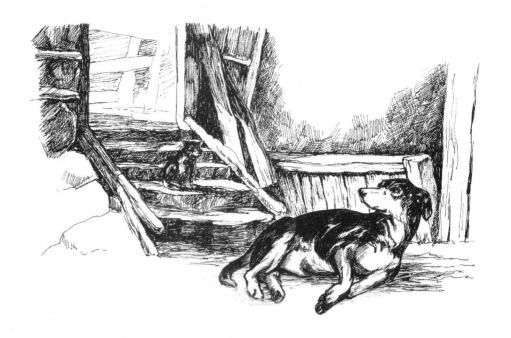

Above, a pen and ink drawing. Below, brush and indian ink.

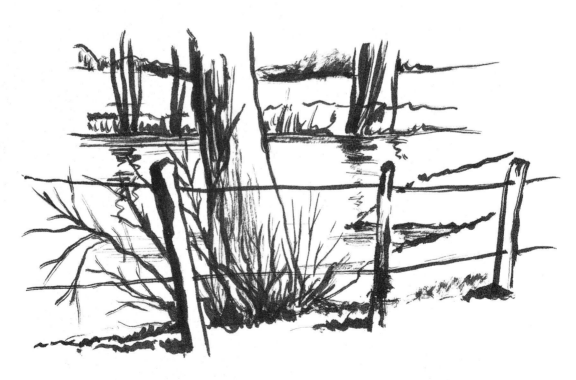

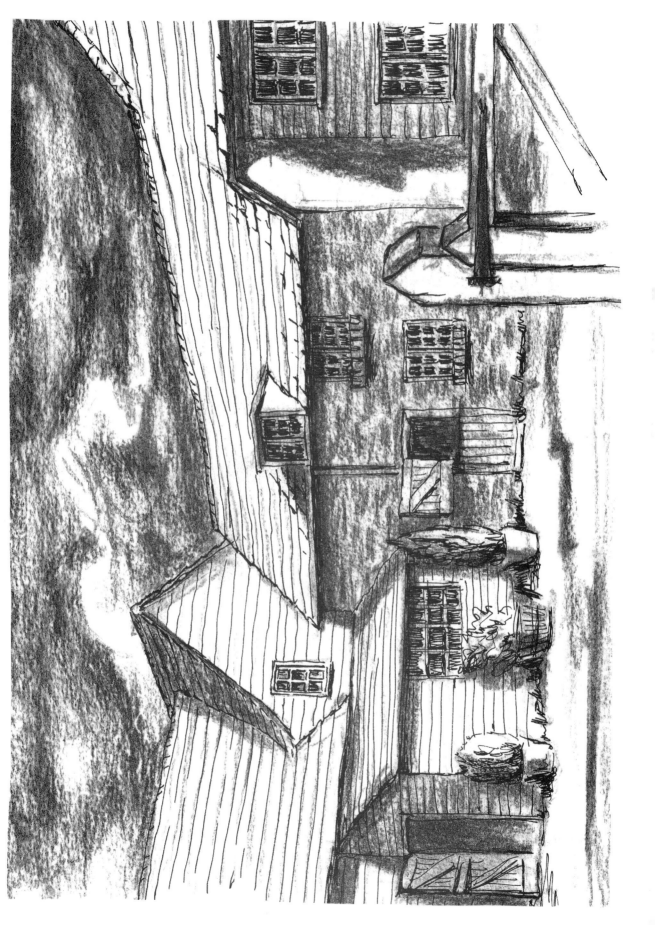

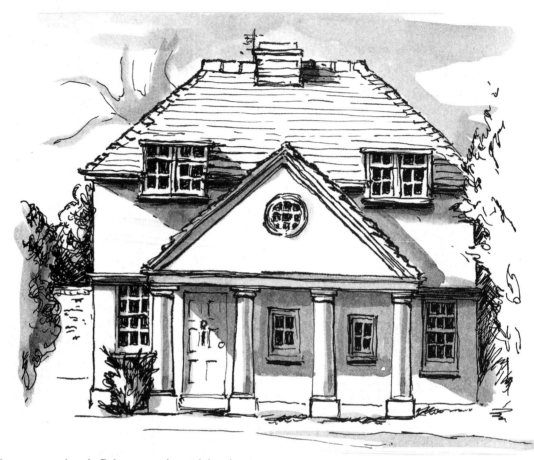

Above, pen and wash. Below, pure charcoal drawing.

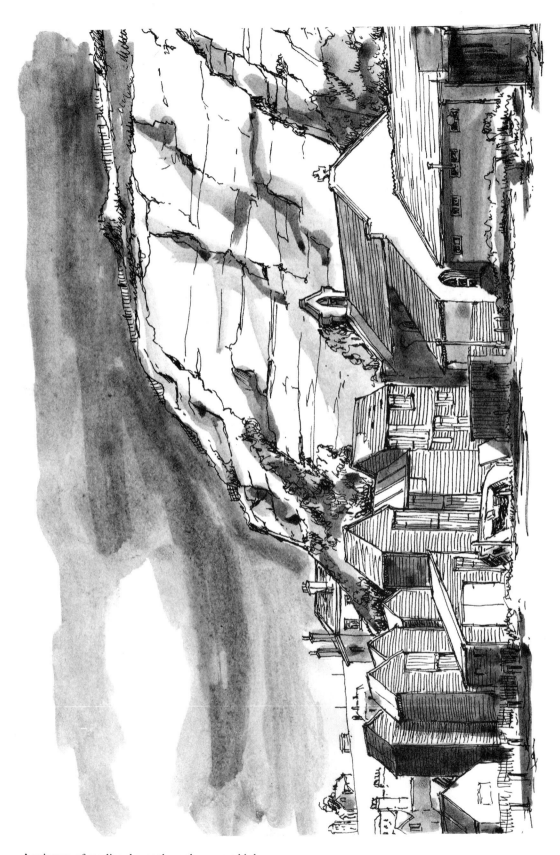

A mixture of media; charcoal, wash, pen and ink

Conclusion

Well, dear reader, if you have persevered to the end of this book I do hope that some of the ideas and illustrations have helped you with your drawing.

Remember that your art is entirely personal and that although the generally accepted 'rules' are there as a starting point, they are by no means sacrosanct. As drawing is very much an intellectual as well as a technical exercise, satisfy yourself by reasoning as well as by sensitivity. Feel is probably the most important. Draw 'by the seat of your pants'.

As a fellow artist once remarked, art is a commitment and should be approached with a certain humility. You should practise your talent and make it grow in your own personal way. You are privileged and must never waste this talent. One other important thing – you are never too old to start.

Now go and enjoy yourself, you will find that soon you will have to draw just as you have to breathe – to be alive.

frog